Kara Walker
After the Deluge

RIZZOLI
NEW YORK

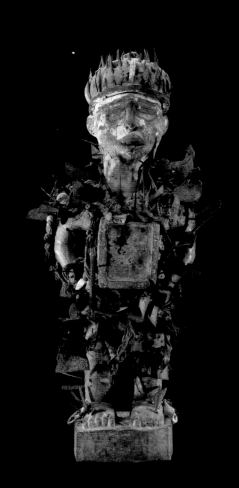

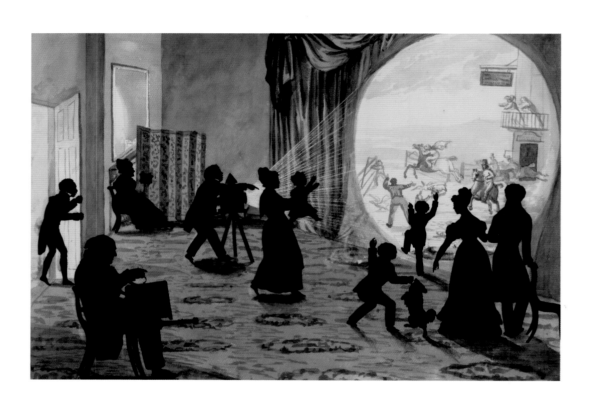

Perhaps Now is the time to
do
away with
pictures of
things
which
engage
our
pleasure
centers,
before
trying to
destroy
them

The story that has interested me is the story of Muck.

At this book's inception,

the narrative of Hurricane Katrina had shifted precariously away from the hyperreal horror show presented to the outside world as live coverage of a frightened and helpless populace (relayed by equally frightened and helpless reporters) to a more assimilable legend. Lately, the narrative of the disaster has turned to "security failures," or "the question of race and poverty," or "rebirth." I've heard harrowing anecdotes of survival and humorous tales of rancid refrigerators. And always at the end of these tales, reported on the news, in newspapers, and by word of mouth, always there is a puddle—a murky, unnavigable space that is overcrowded with intangibles: shame, remorse, vanity, morbidity, silence.

We tell stories of events to allude to the unspeakable.

Rumors and jokes fill in the uncomfortable, antisocial gaps. Vulnerability, failure, panic tell of themselves through careful observation of things like body language and eye contact. I've seen music, dance, and Mardi Gras celebrations activate damaged, closed-off psychic spaces; they provide hope. But what role can the visual arts play in reexamining one of America's greatest social failures? "Not much" is the pessimistic conclusion I came to, followed by a close examination of a line of

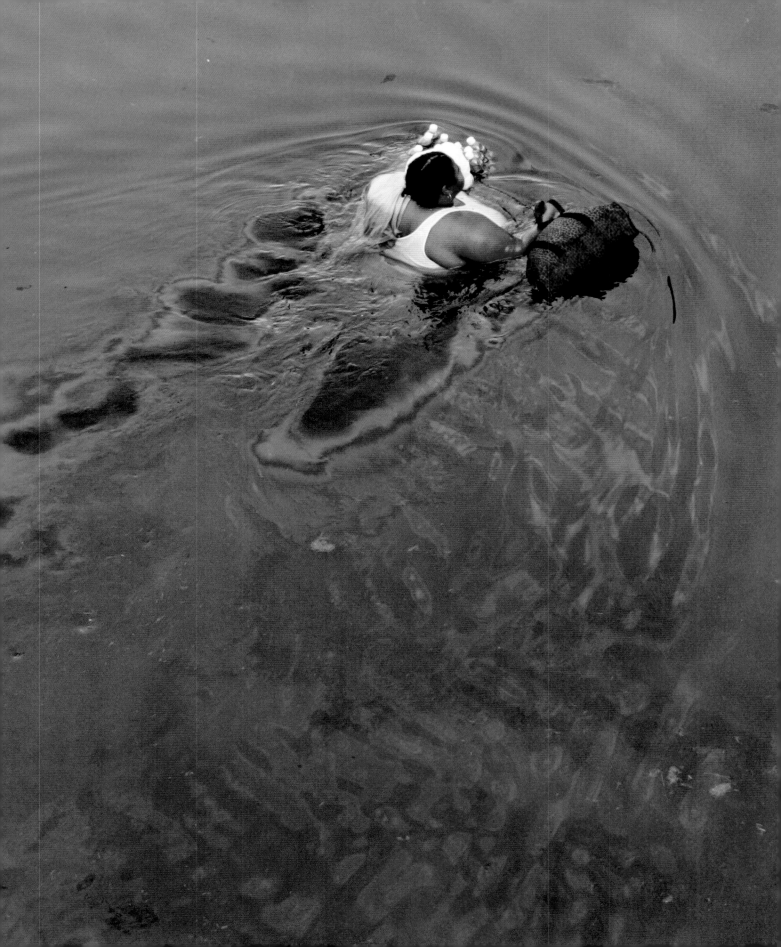

thinking familiar to Blacks, as expressed by my grandmother: "All you have to do in this world is stay Black and die." This phrase sums up multilayered experiences of suppression, resentment, and rage. I have asked the objects in this book to do one more thing. Instead of sitting very still, "staying Black," and waiting to die, I have asked each one to take a step beyond its own borders to connect a series of thoughts together related to fluidity and the failure of containment.

This book is not simply about New Orleans or

Katrina or waterborne disaster. It is an attempt to understand the subconscious narratives at work when we talk about such an event. I have cobbled together from the Metropolitan Museum of Art's collection (as well as two works from the Museum of Fine Arts, Boston) and from some of my own work a narrative of fluid symbols in which that fluidity is figurative and sometimes literal. Black life, urban and rural Southern life, is often related as if it were an entity with a shadowy beginning and a potentially heroic future, but with a soul that is crippled by racist psychosis. One theme in my artwork is the idea that a Black subject in the present tense is a container for specific pathologies from the past and is continually growing and feeding off those maladies. Racist pathology is the Muck, aforementioned. In this book's analogy, murky, toxic waters become the amniotic fluid of a potentially new and difficult birth, flushing out of a coherent and stubborn body long-held fears and suspicions.

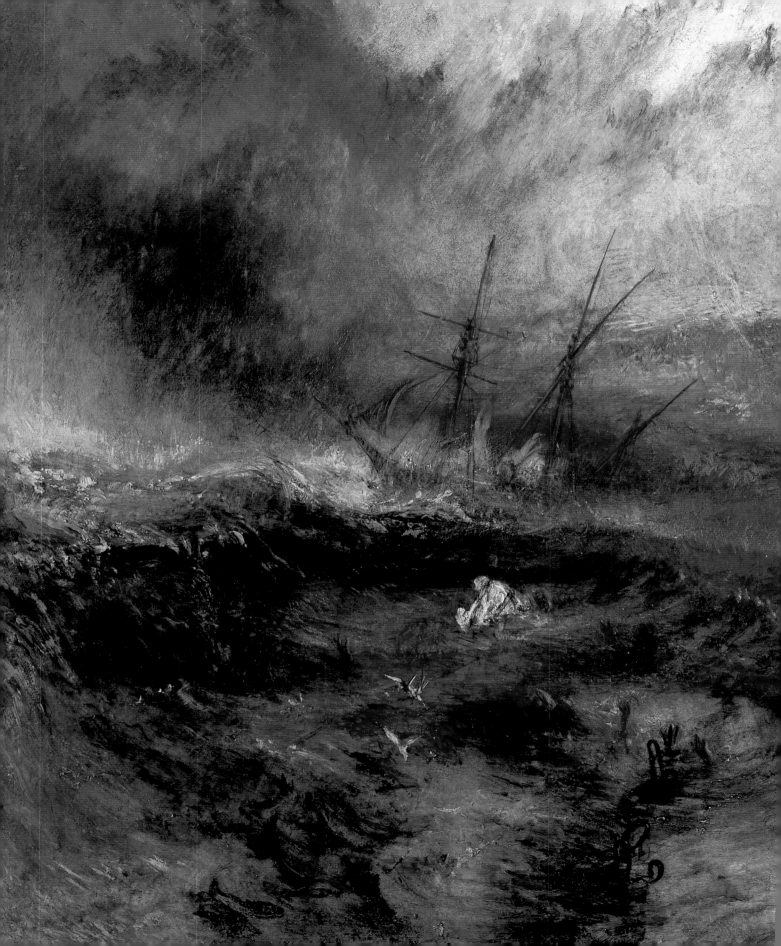

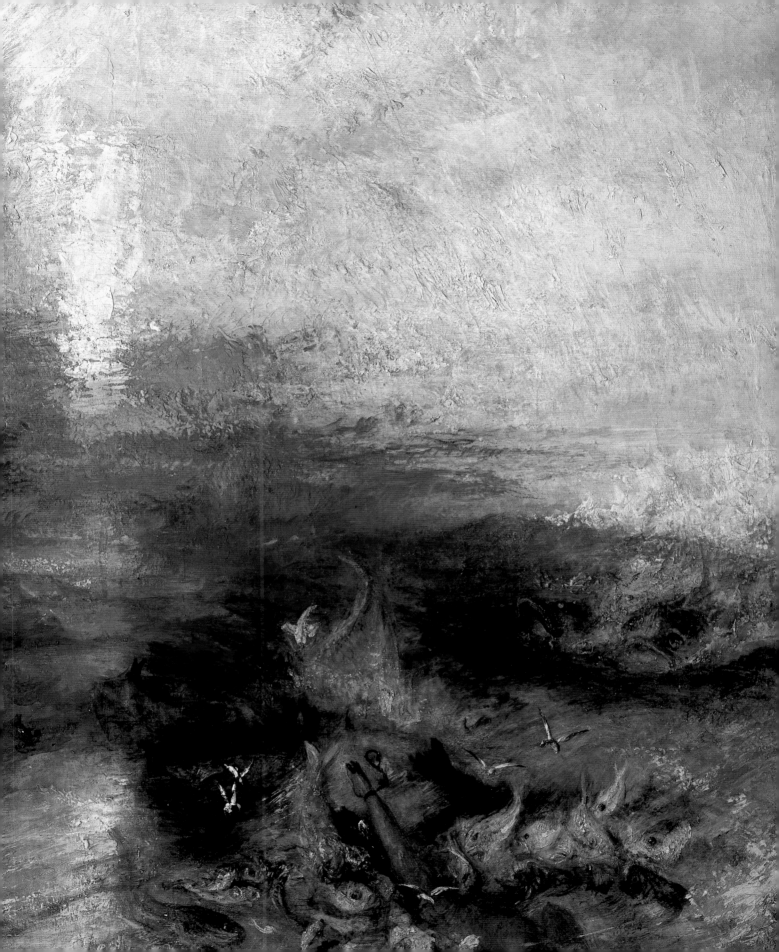

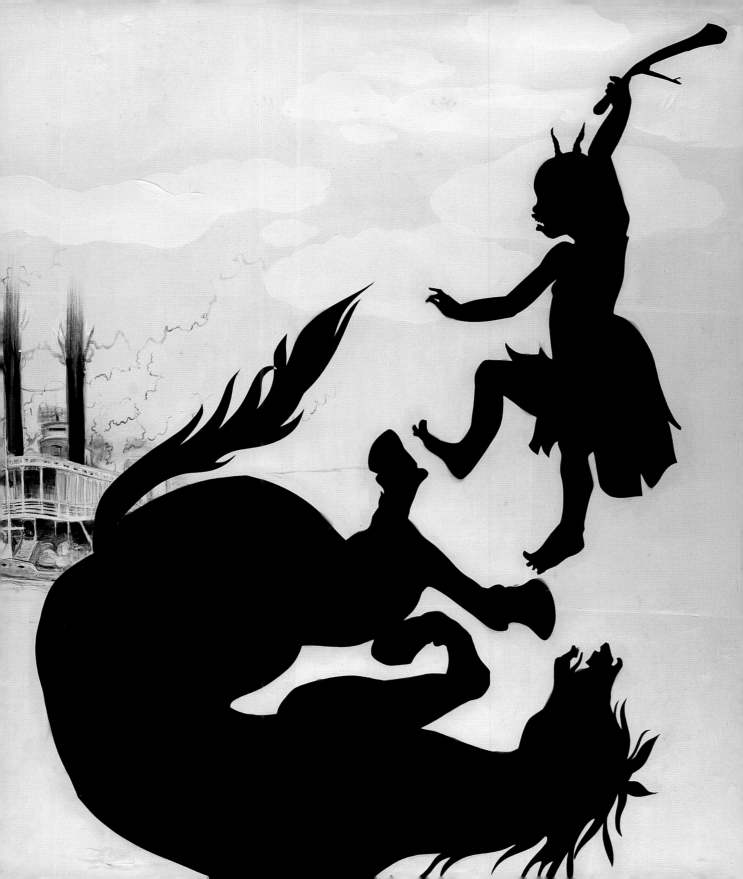

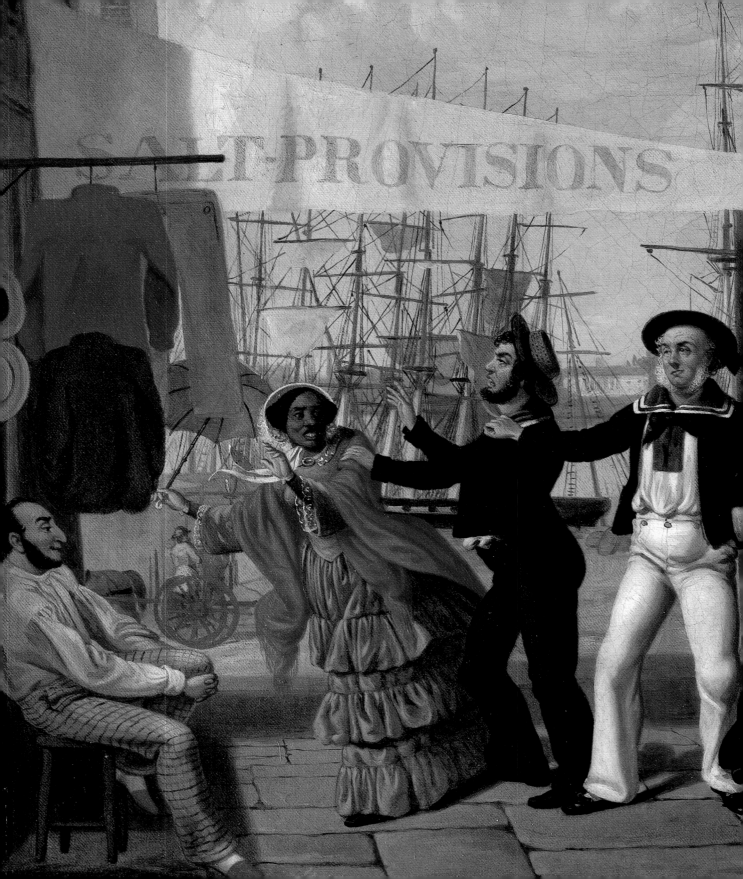

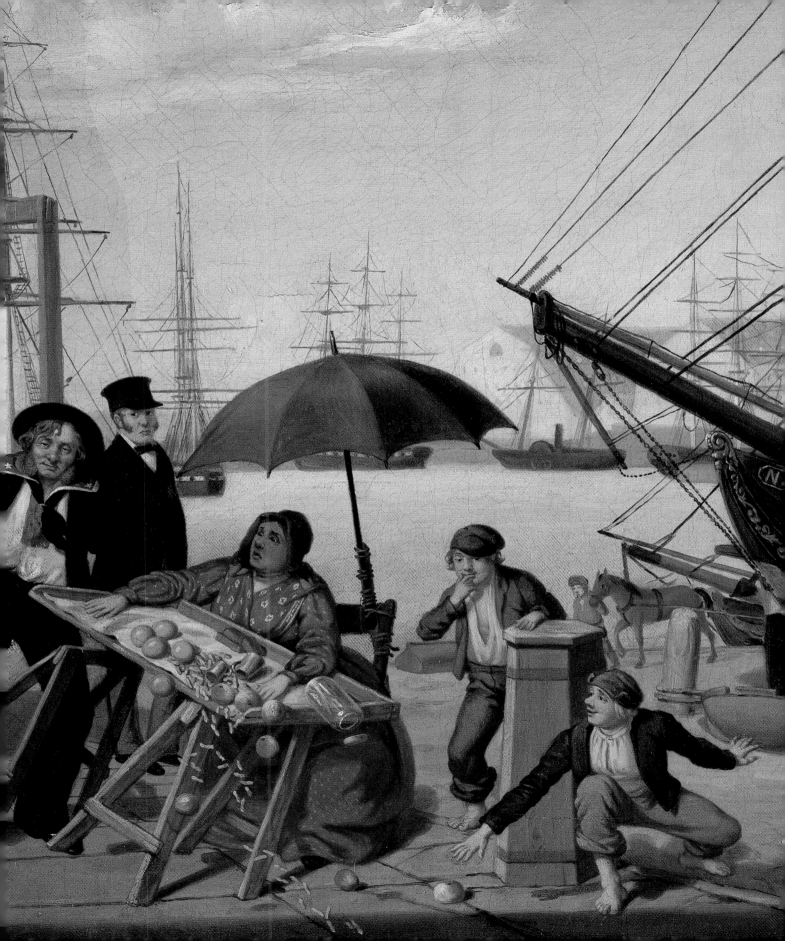

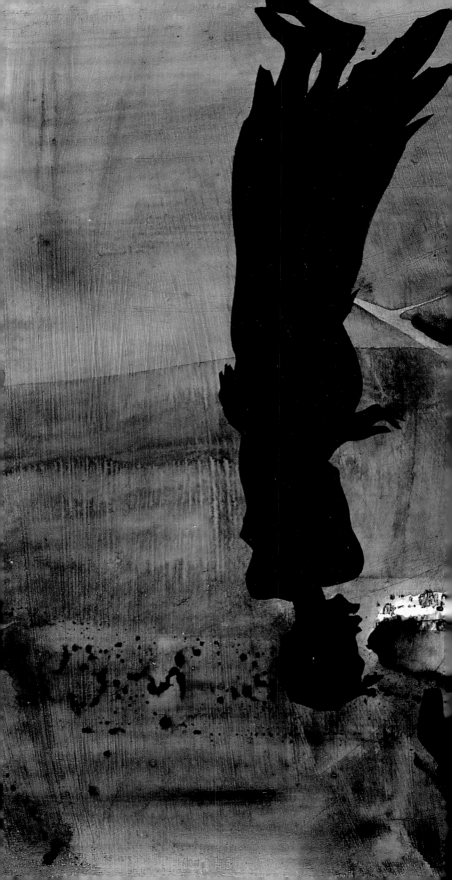

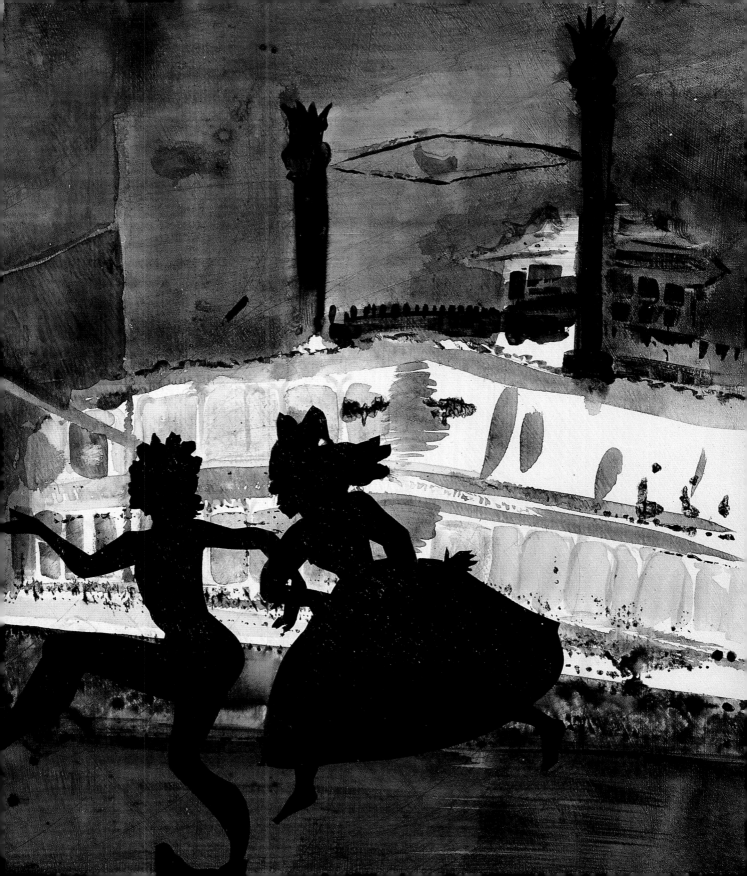

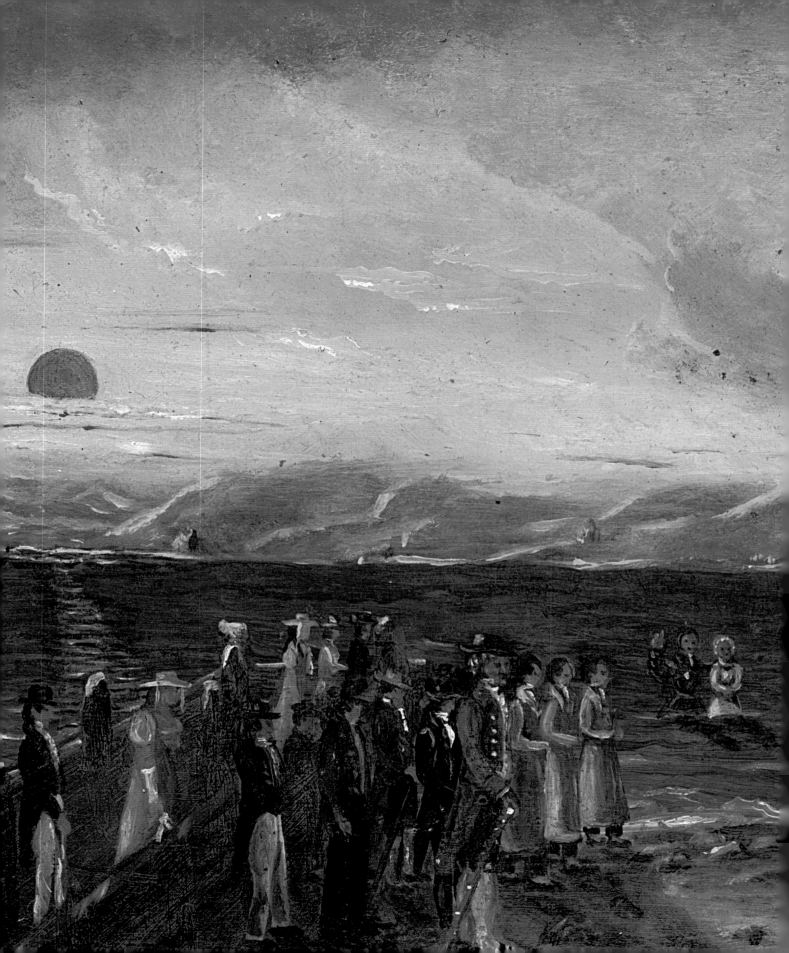

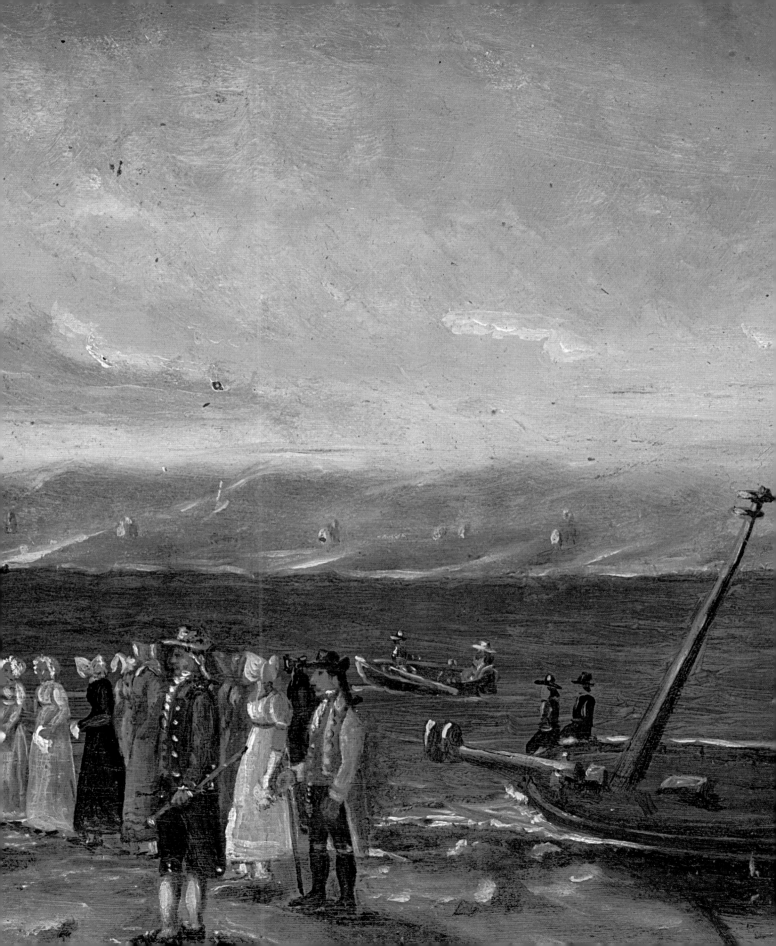

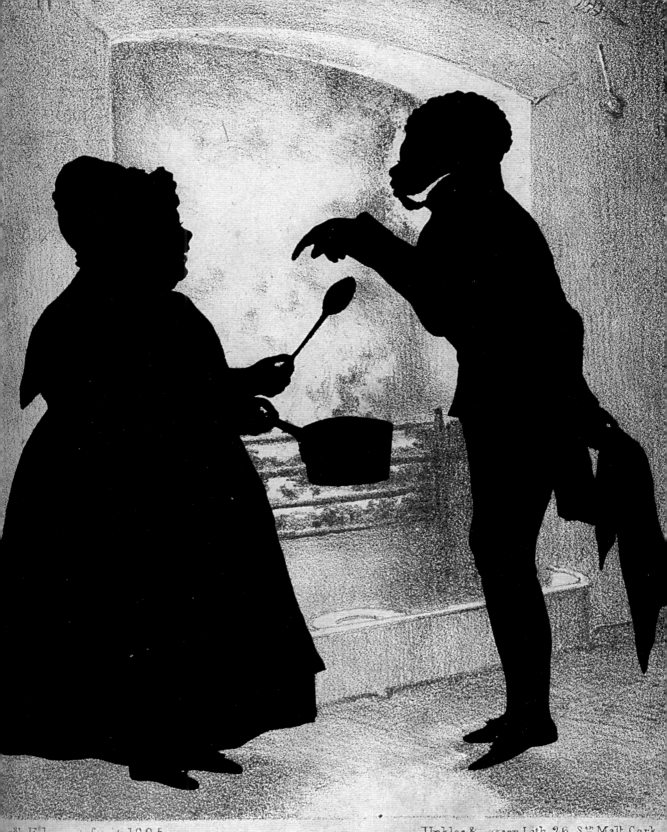

Unkles & ..sen Lith. 26 S.t. Mall, Cork.

JOHN'S FUNNY STORY TO MARY THE COOK.

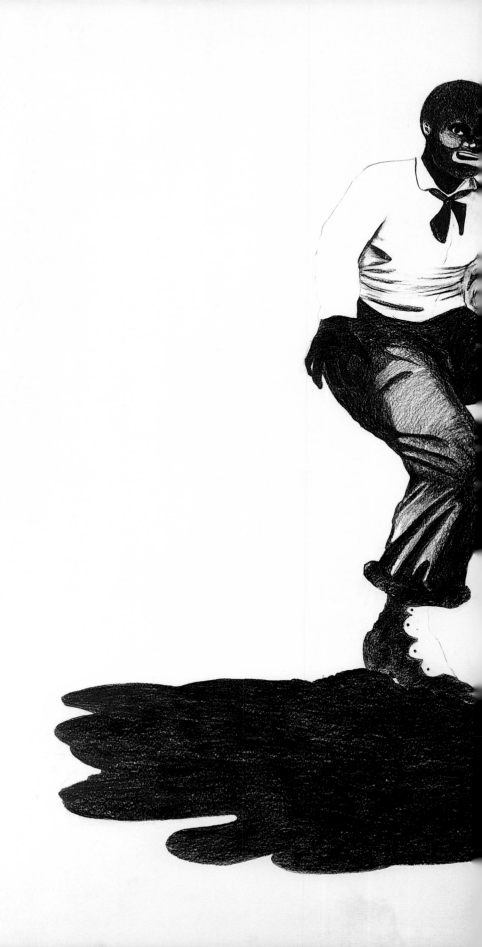

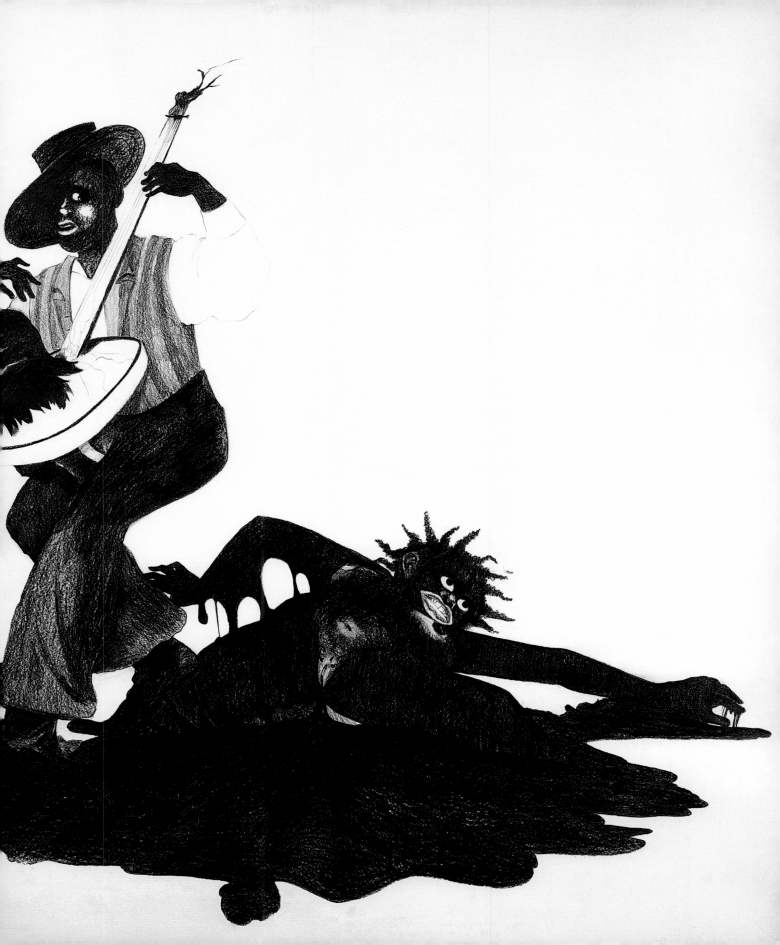

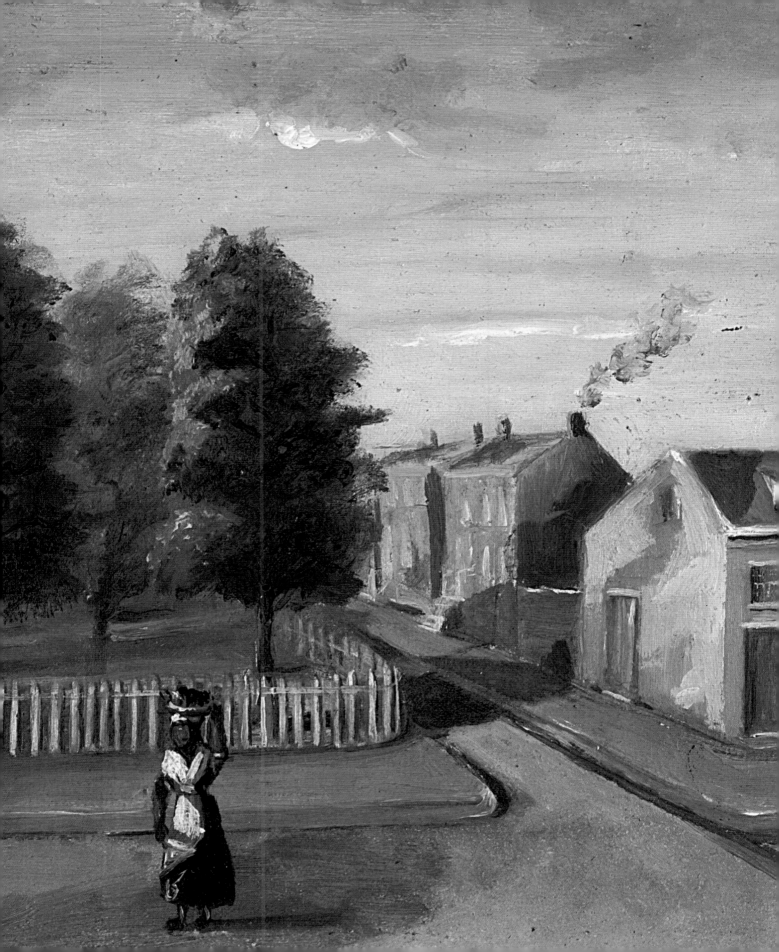

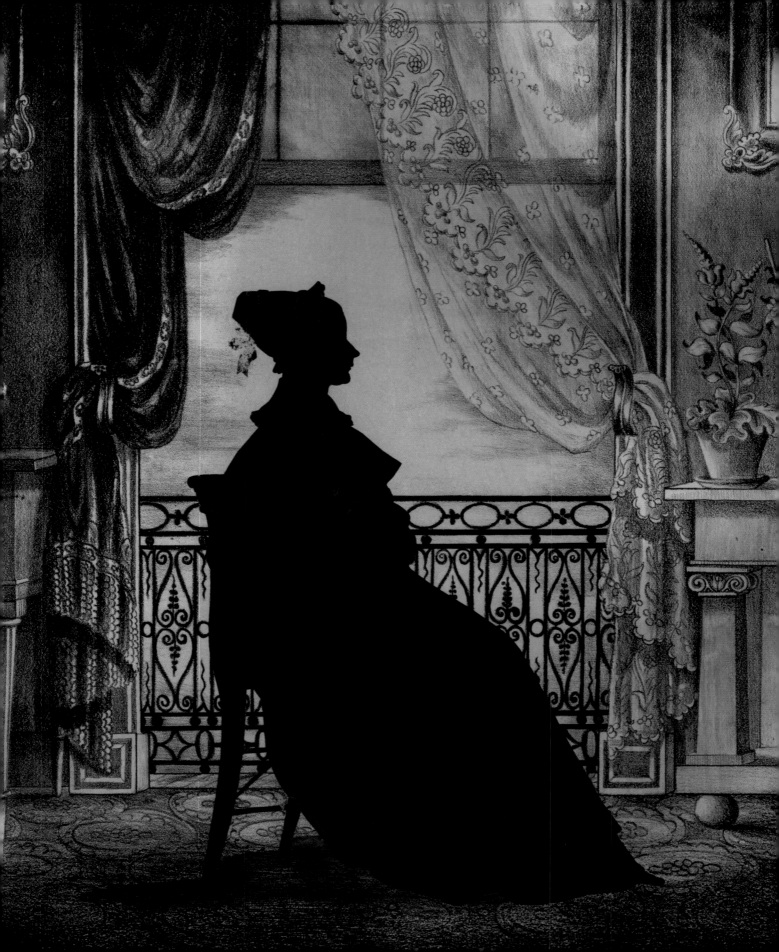

0

27

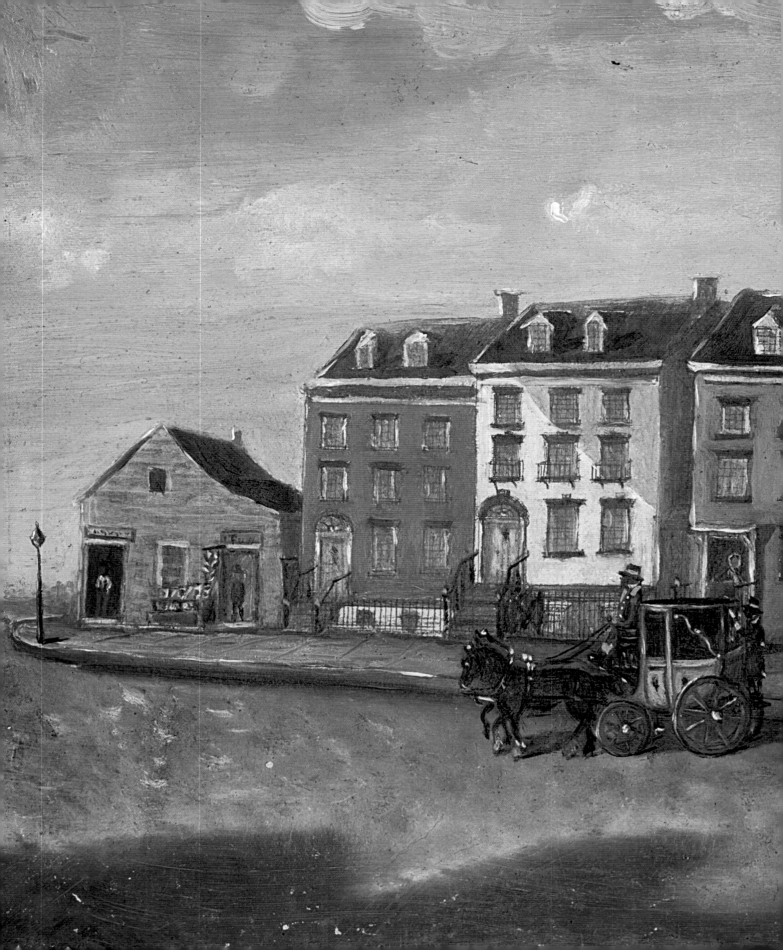

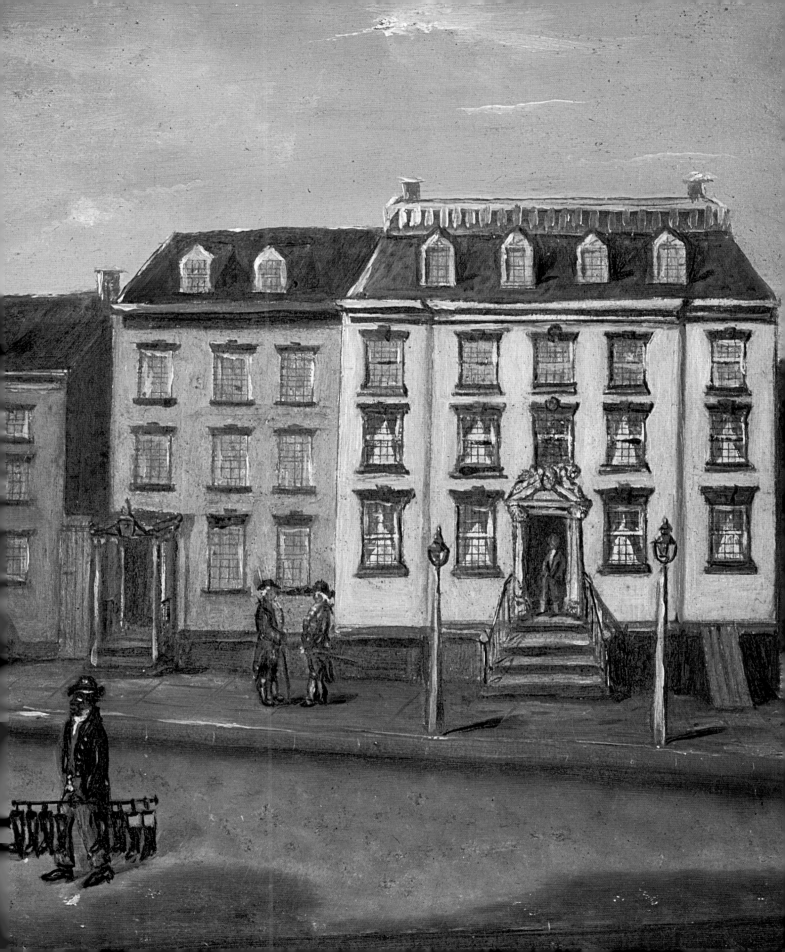

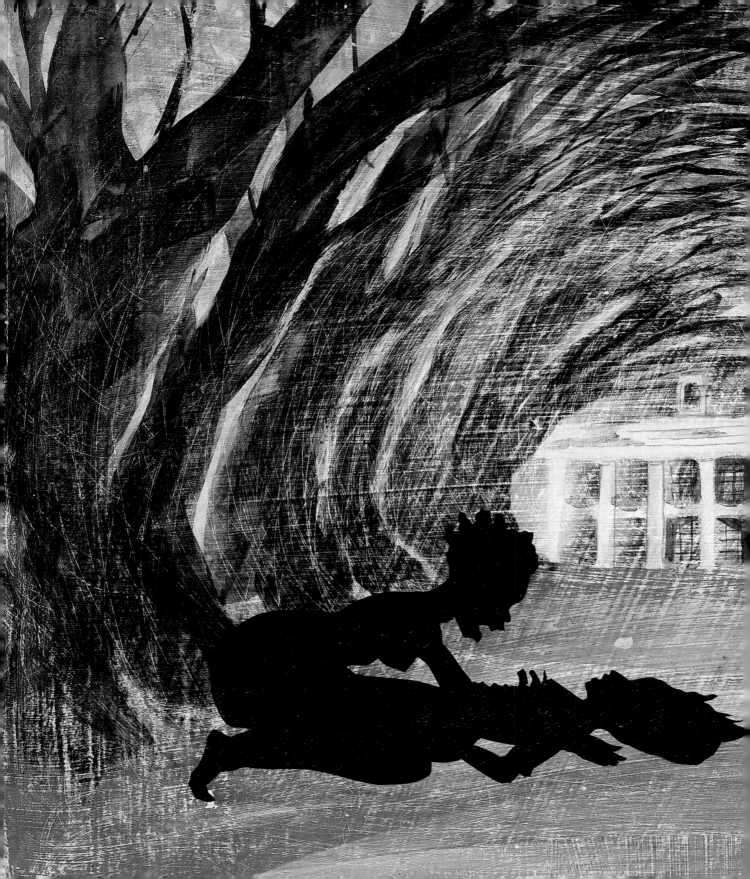

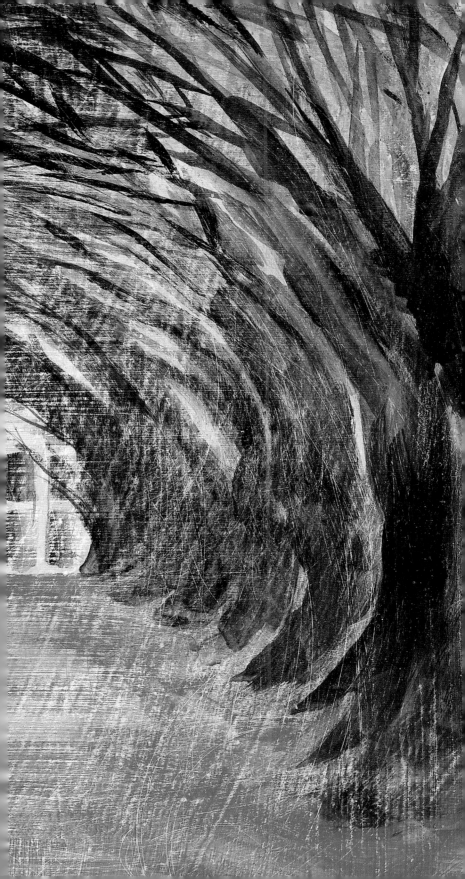

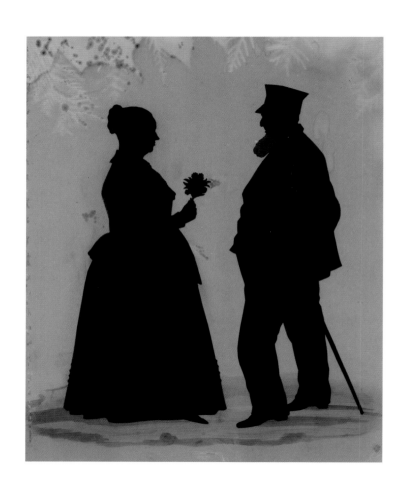

Dear Cruel and malevolent Master,

What irks me, you know this, is that I am and forever shall be a slave to that which ~~brought (said: "brung~~ "brung") me here.

And while I know that the better part of me understands - um- that thing you say that-

I am more than just a product of black history or American history, or Womens Liberation...

But I am enough of a product of these movemen‑
ts to suspect you of undermining me for
saying so.

And, please excuse, it may simply be
a flaw of the personality that I am docile,
meek, shy and sympathetic, "sweet" and "good"
(and Pretty, you said)

but when I gits my Affikin Up

then I know that Whatever personlaity I may
possess is simply the collage effect of
too many meaningful documentaries.

... and plenty of knowing glances.

As you rightly suspected far too much of this History of mine (which fatigues you so, this February) was not passed down orally, was in fact, unspoken. Was simply gestured, not even the courtesy of a whisper, nodded in broad daylight, under the yves of the big house, near the live Oak which we all stood around whilst pappy got his bruising, tied to, and

I I forget waht I was saying.

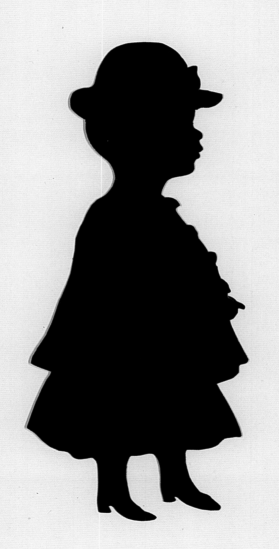

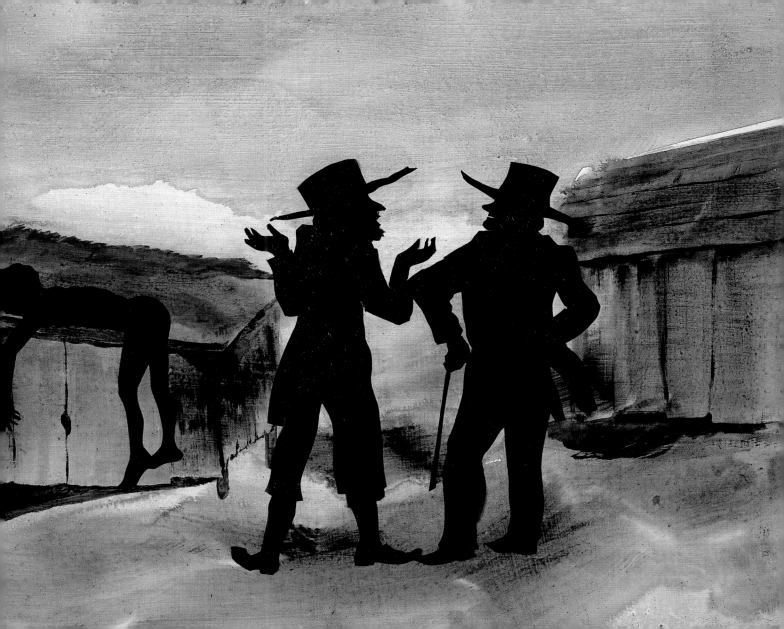

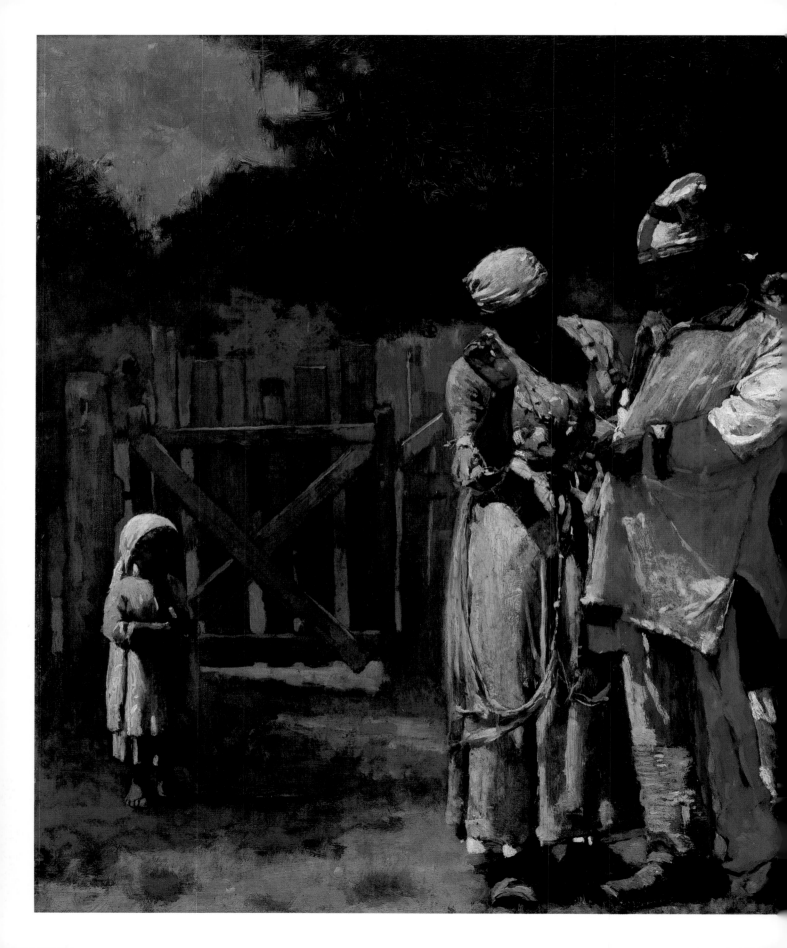

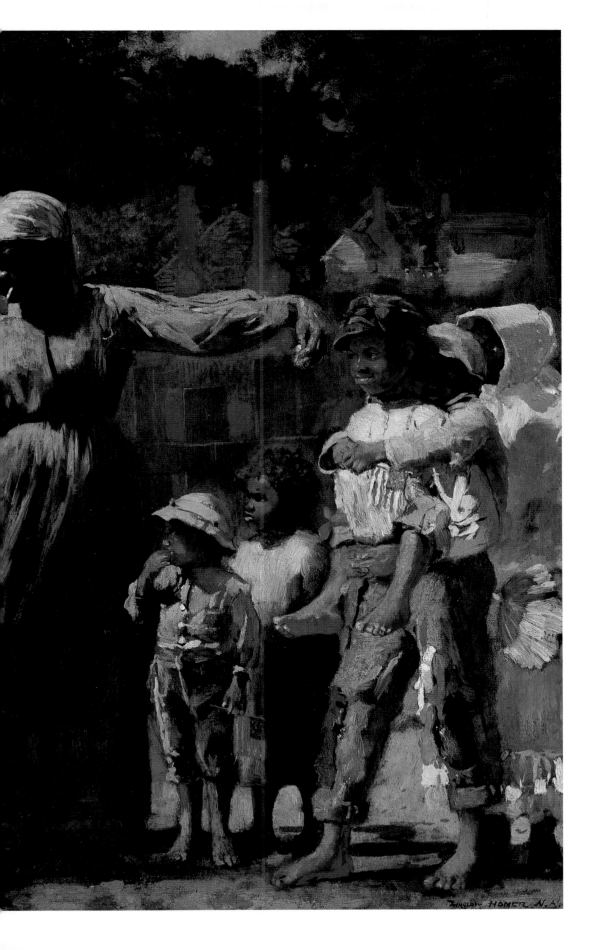

 Like simon Legree, the bad man—
I is haunted by demons of my own devising

This leaves me vulnerable to the simple
threats of children and inferiors, who
tease the cracks in my walled fortress-like
reserve

Because worse than you bein' my nemisis, my
servant or a turncoat

Is the possibility of yer bein' a innocent.

Ah spends mah days thinkin you maught be
immature, in need of Christian Law, even wild
and capable of the worst savagery
but—
lesser than, not equal to
and—
i find, that I Need you
to be this, that I may prosper and multiply

Blend the strength in my Race to the weakness
in yours. Mixing Blood and Semen, may be the
worst sin, but 'tis the one I'm obliged to
commit, by dint of history.

Ah, history which dictates Free trade in
human skin, you see what I'm sayin?

I needs you to not know the potency I imbue you
with, but I needs you to perform just the
same.

I needs you to be clear on that I'm the Master
I make the language—
but without never sayin it.

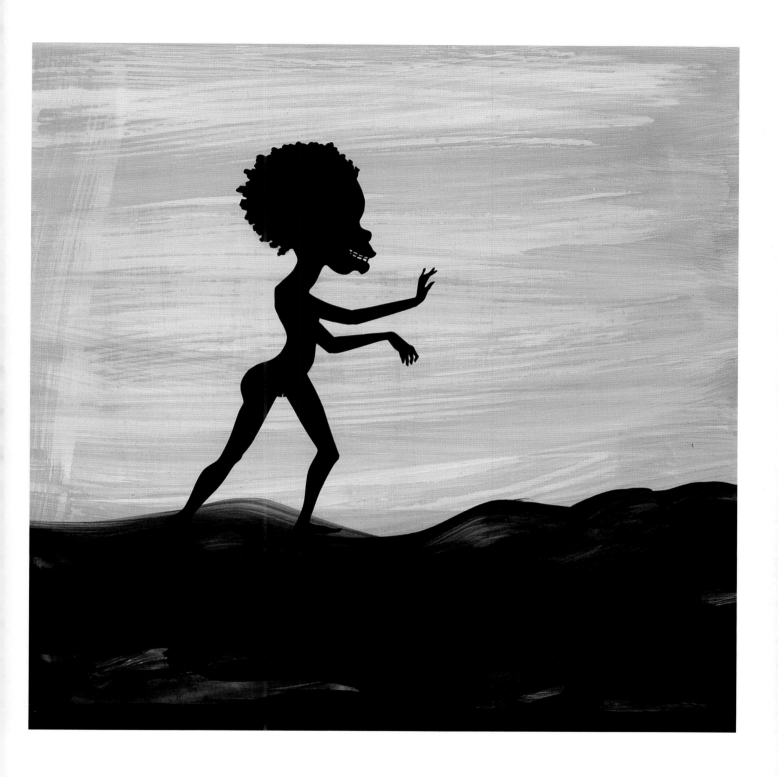

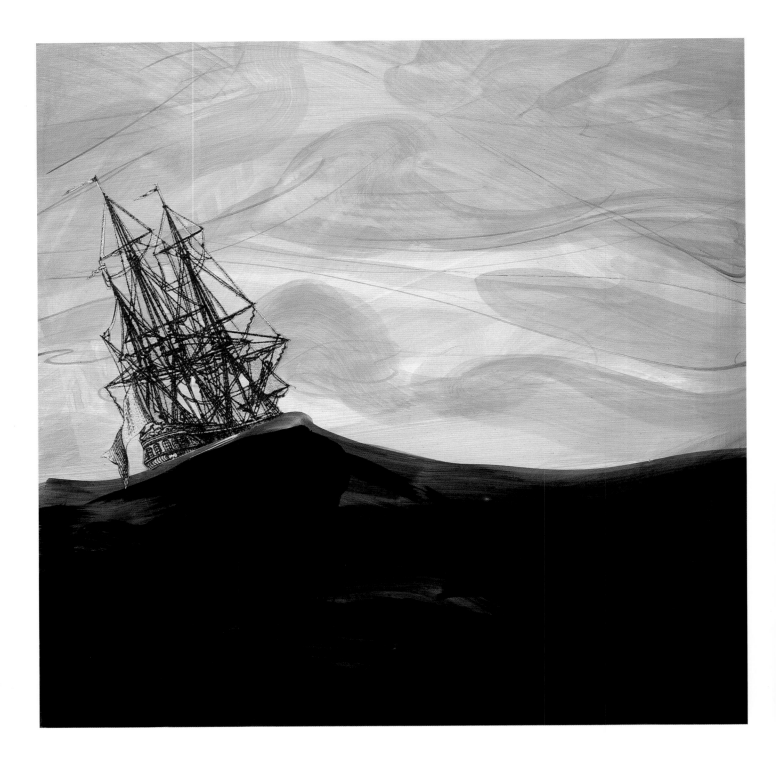

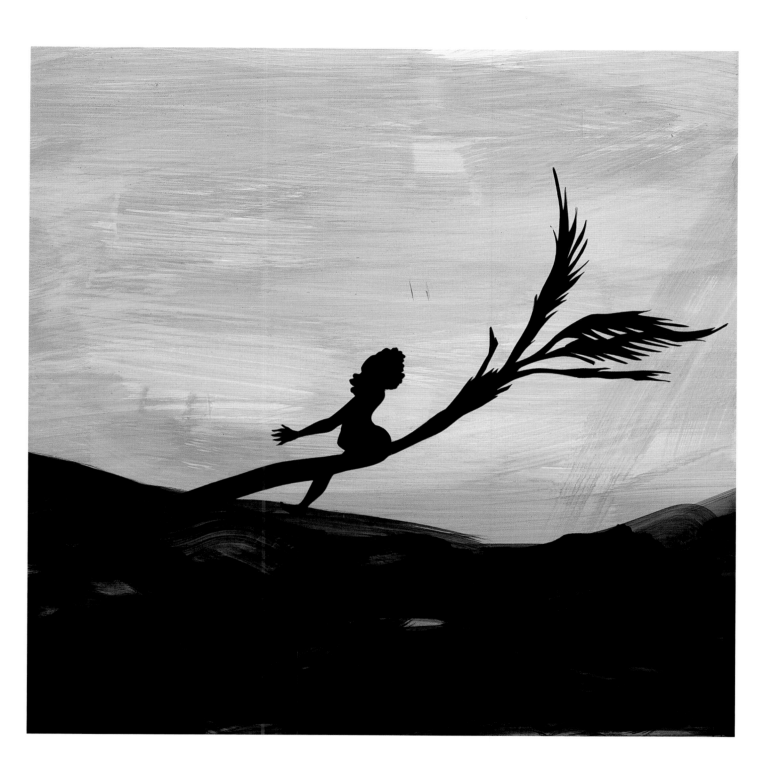

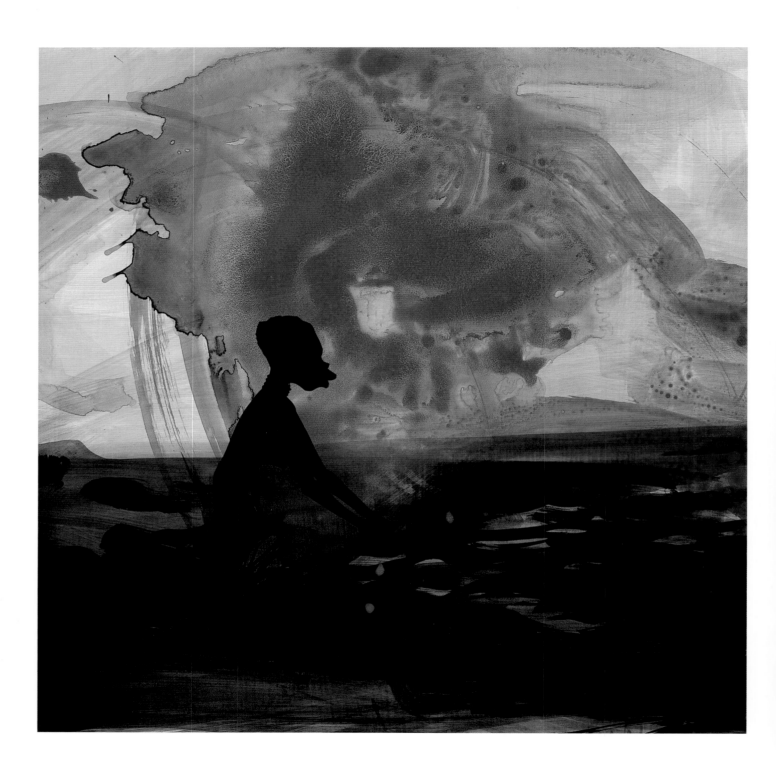

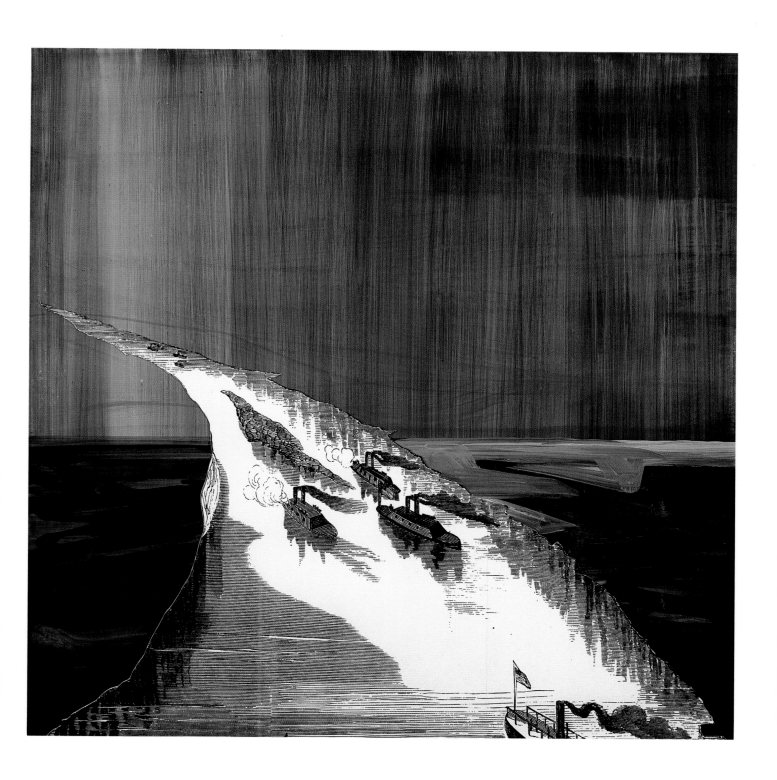

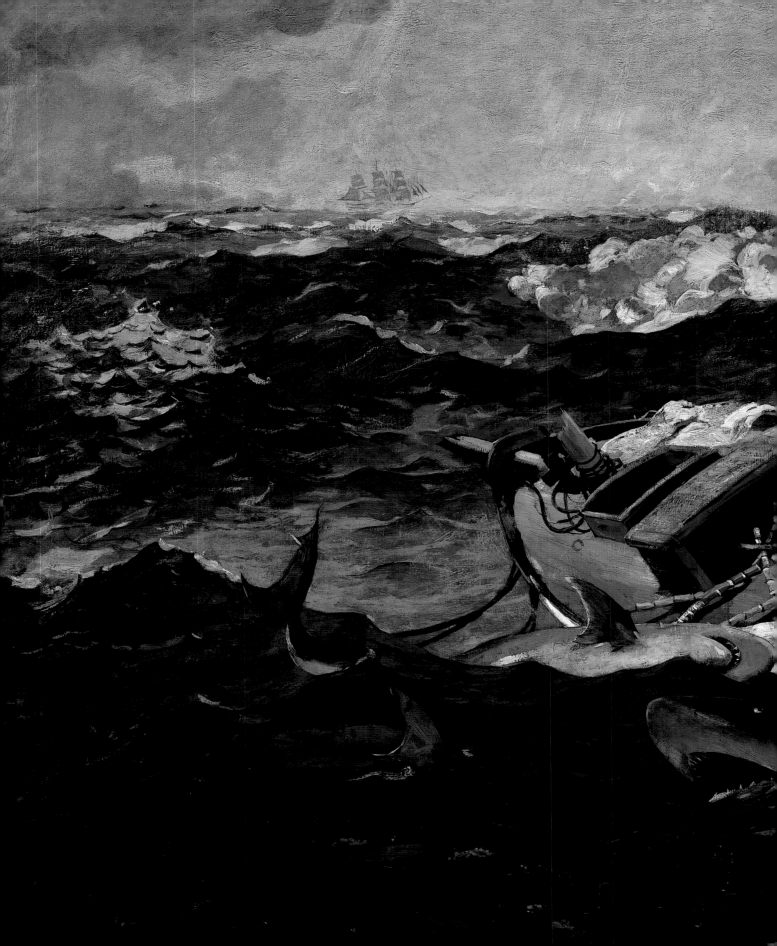

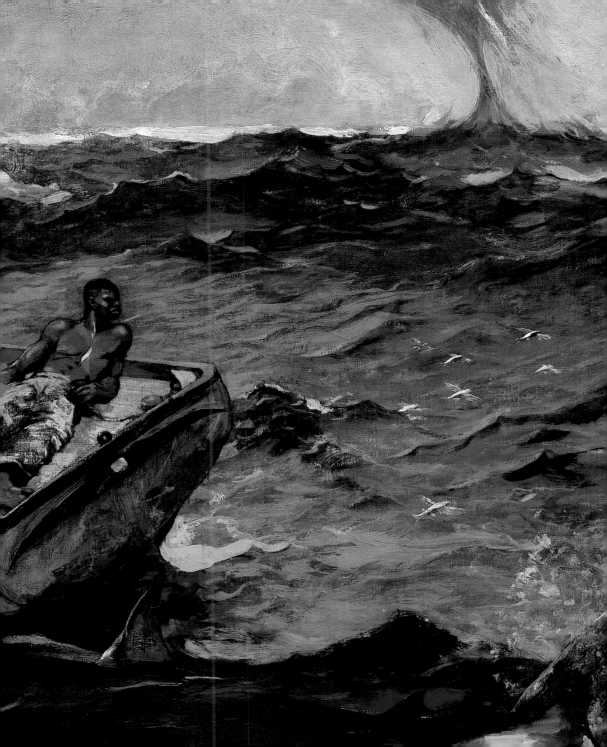

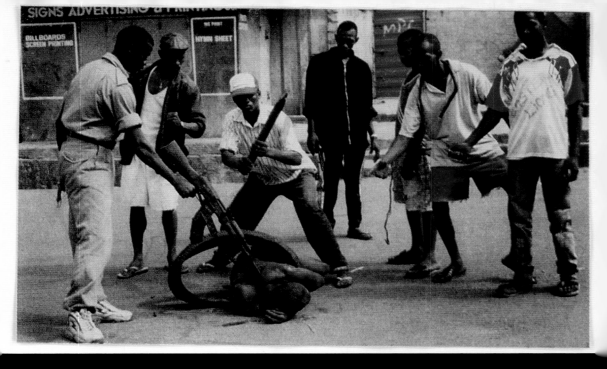

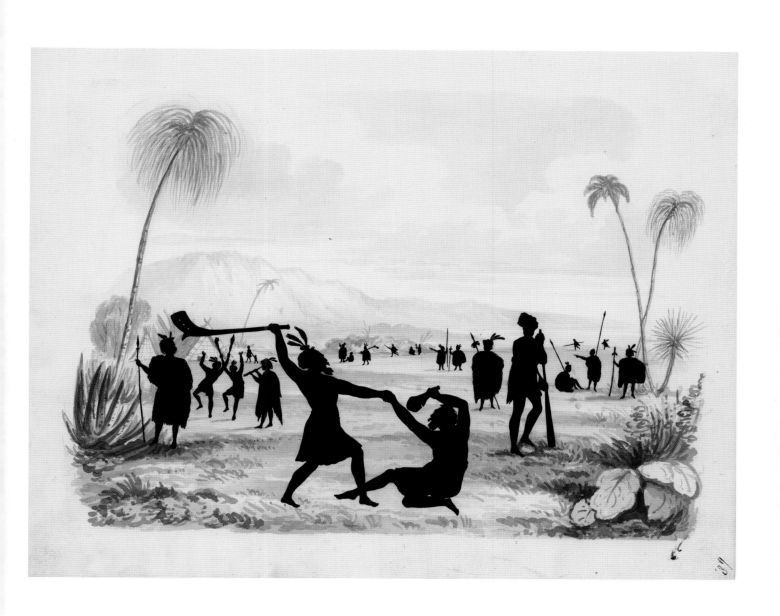

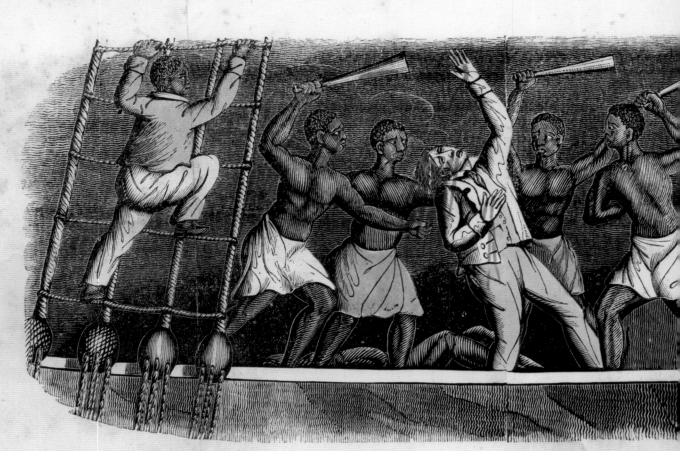

Death of Capt. Ferrer, the Ca

Don Jose Ruiz and Don Pedro Montez, of the Island of Cuba, havin,
on board the Amistad, Capt. Ferrer, in order to transport them to Prin
four days, the African captives on board, in order to obtain their freed
Captain and crew of the vessel. Capt. Ferrer and the cook of the vesse

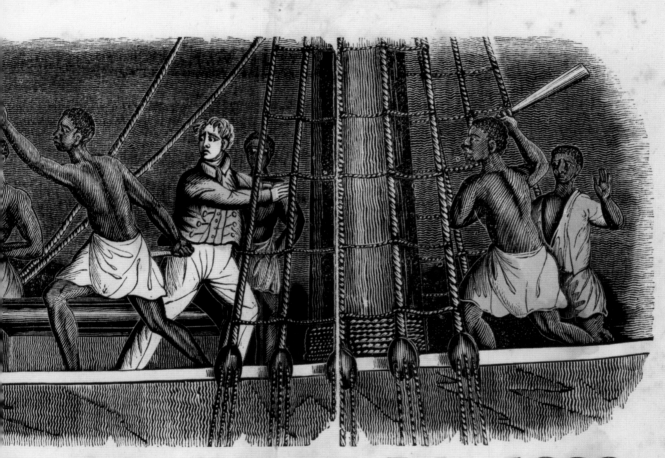

in of the Amistad, July, 1839.

ased fifty-three slaves at Havana, recently imported from Africa, put them
other port on the Island of Cuba. After being out from Havana about
return to Africa, armed themselves with cane knives, and rose upon the
killed; two of the crew escaped; Ruiz and Montez were made prisoners.

A HISTORY

OF THE

AMISTAD CAPTIVES:

BEING A

CIRCUMSTANTIAL ACCOUNT

OF THE

CAPTURE OF THE SPANISH SCHOONER AMISTAD,

BY THE AFRICANS ON BOARD;

THEIR VOYAGE, AND CAPTURE

NEAR LONG ISLAND, NEW YORK; WITH

BIOGRAPHICAL SKETCHES

OF EACH OF THE SURVIVING AFRICANS.

ALSO, AN ACCOUNT OF

THE TRIALS

HAD ON THEIR CASE, BEFORE THE DISTRICT AND CIRCUIT COURTS OF THE
UNITED STATES, FOR THE DISTRICT OF CONNECTICUT.

COMPILED FROM AUTHENTIC SOURCES,

BY JOHN W. BARBER,

MEM. OF THE CONNECTICUT HIST. SOC.

NEW HAVEN, CT.:
PUBLISHED BY E. L. & J. W. BARBER.
HITCHCOCK & STAFFORD, PRINTERS.

1840.

er sold him for a coat. He was taken in the night, and was taken a six days' journey, and sold to Garlobá, who had four wives. He staid with this man two years, and was employed in cultivating rice: His master's wives and children were employed in the same manner, and no distinction made in regard to labor.

(12.) **Ses-si**, 5 ft. 7½ in. with a sly and mirthful countenance, was born in Massa-kum, in the Bandi country, where his king, *Pa-ma-sa*, resided. He has three brothers, two sisters, a wife, and three children. He is a blacksmith, having learnt that trade of his brother; he made axes, hoes, and knives from iron obtained in the Mendi country: He was taken captive by soldiers and wounded in the leg. He was sold twice before he arrived at Lomboko, where he was kept about a month: Although a Bandi, he appears to have been able to talk in Mendi.

(13) **Mo-ru**, middle age, 5 ft. 8½ in. with full negro features, was born at Sanka, in the Bandi country: His parents died when he was a child. His master, Margoná, who sold him, had ten wives and many houses; he was twenty days on his journey to Lomboko. He was sold to Be-le-wa, (*great whiskers*,) i. e. to a Spaniard.

(14.) **Ndam-ma**, (*put on, or up*,) 5 ft. 3 in. a stout built youth, born in the Mendi country, on the river Ma-le. His father is dead, and he lived with his mother; has a brother and sister. He was taken in the road by twenty men, and was many days in traveling to Lomboko.

No. 15. No. 16. No. 17.

(15.) **Fu-li-wu-lu**—*Fuli*, or, as the name has been written, Furie, (*sun*,) called Fuliwulu, to distinguish him from Fuliwa, (*great Fuli*,) lived with his parents in the Timmani, near the Mendi country. He is the son of Pie, (No. 10.) He was taken with his father, by an African, who sold him to a Bullom man, who sold him to Luis, a Spaniard at Lomboko. He has a depression in the skull from a wound in the forehead. 5 ft. 2½ in. in height.

(16.) **Ba-u**, (*broke*,) 5 ft. 5 in. high, sober, intelligent looking, and rather slightly built. Has a wife and three children. He was caught in the bush by 4 men as he was going to plant rice; his left hand was tied to his neck; was ten days in going to Lomboko. He lived near a large river named Wo-wa. In his country all have to pay for their wives; for his, he had to pay 10 clothes, 1 goat, 1 gun, and plenty of mats; his mother made the cloth for him.

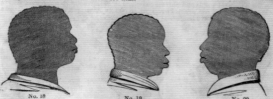

No. 18. No. 19. No. 20.

17. **Ba**, (*have none*,) 5 ft. 4½ in. with a narrow and high head; in middle life. Parents living, 4 brothers and 4 sisters; has got a wife and child. He is a planter of rice. He was seized by two men in the road, and was sold to a Gallina Vai man, who sold him to a Spaniard. High mountains in his country, but small streams; cotton cloth is manufactured, and hens, sheep, goats, cows, and wild hogs, are common.

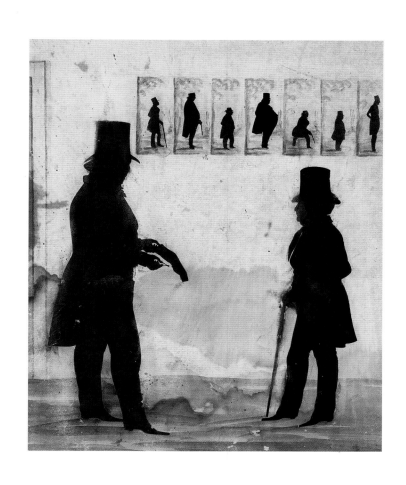

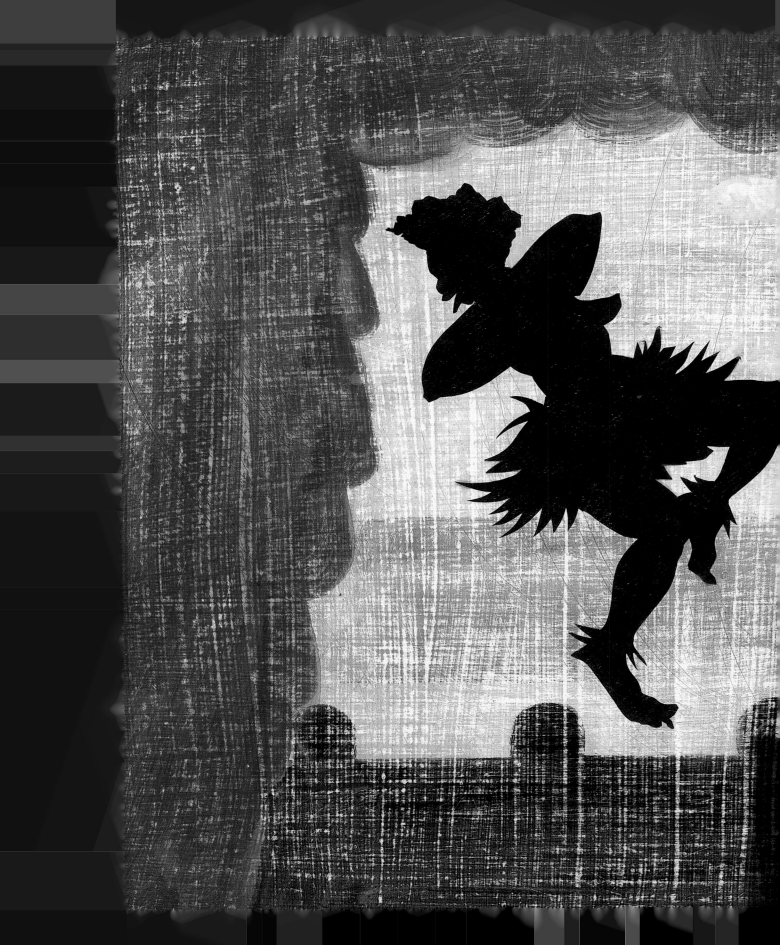

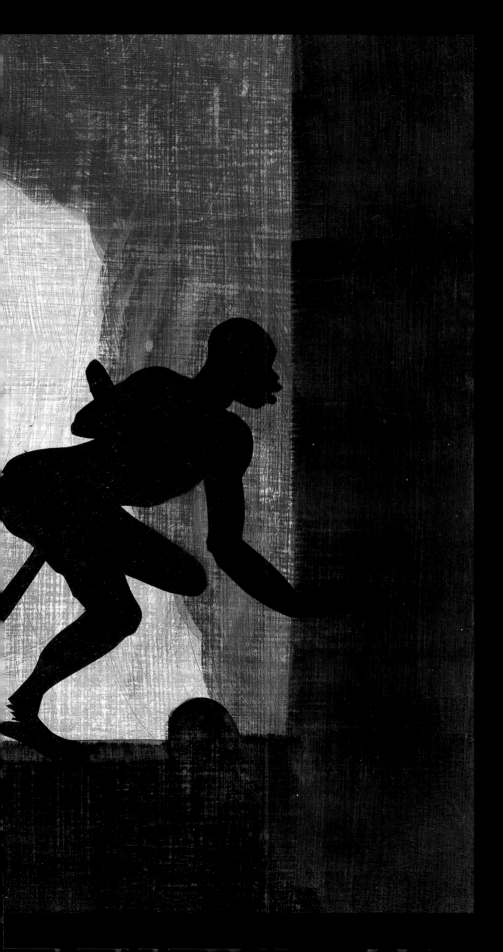

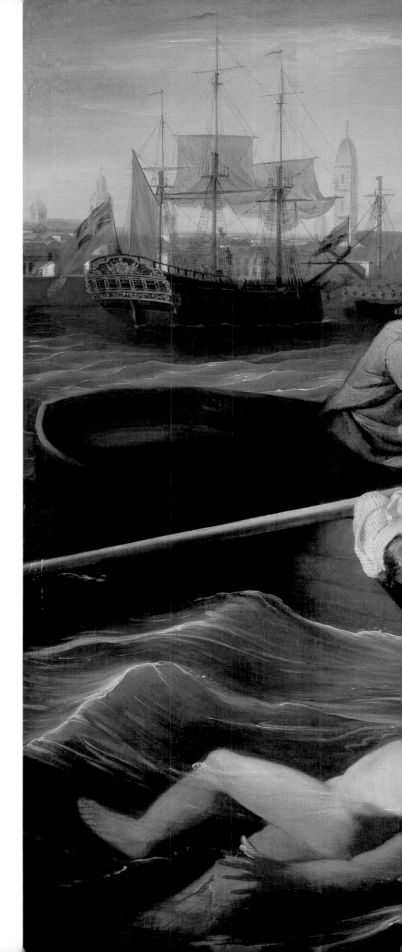

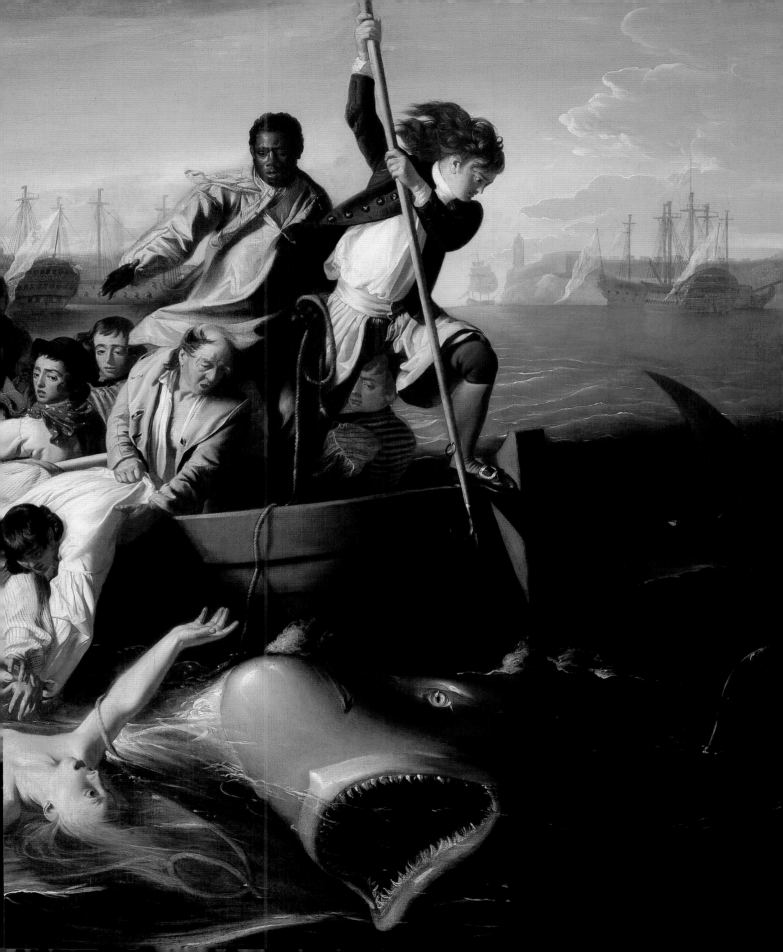

No. 16.

No. 22.

No. 17.

No. 15.

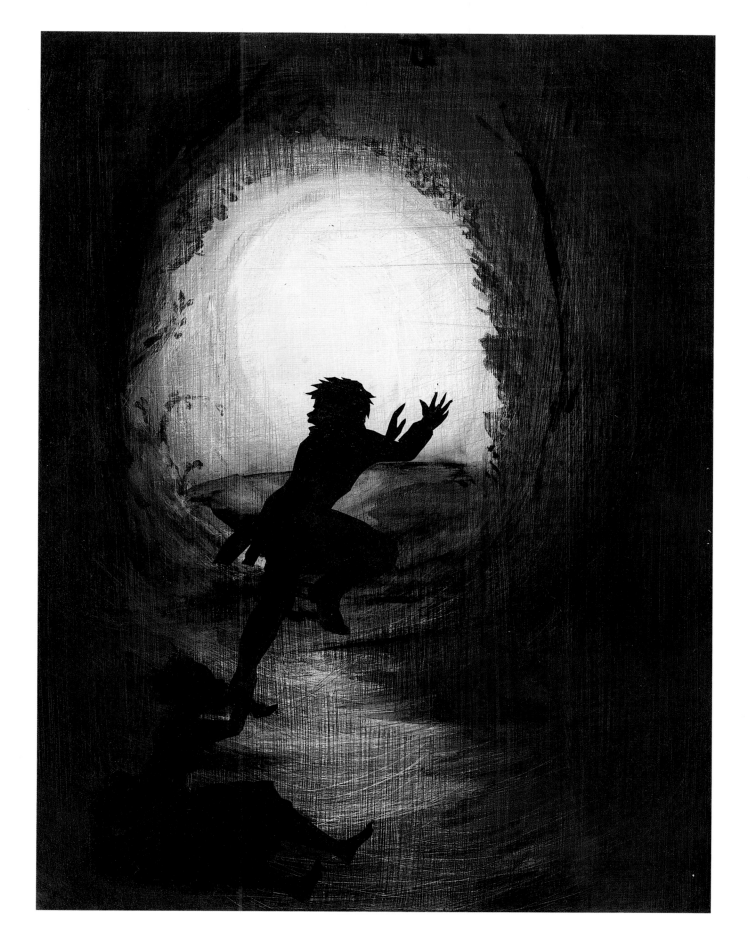

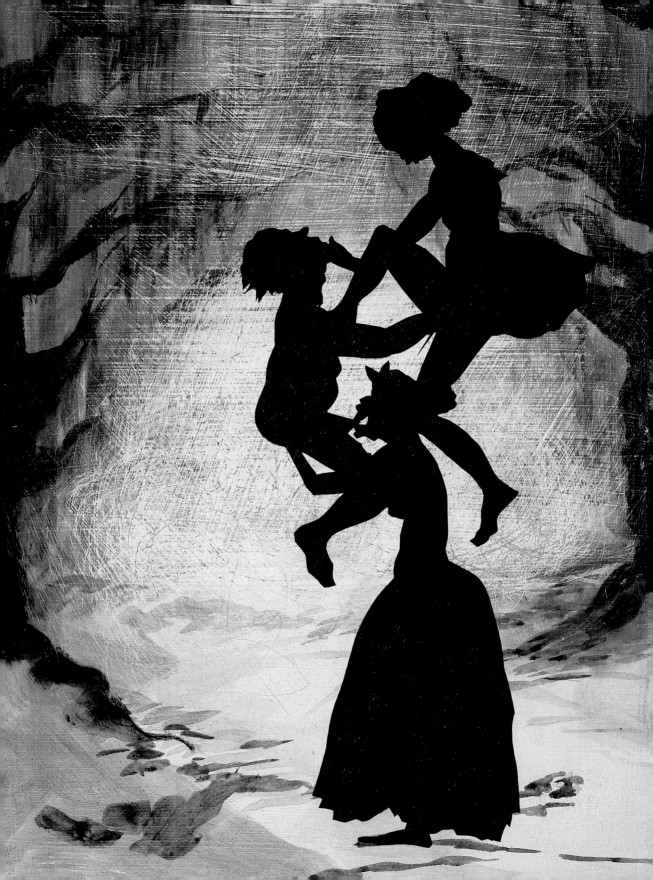

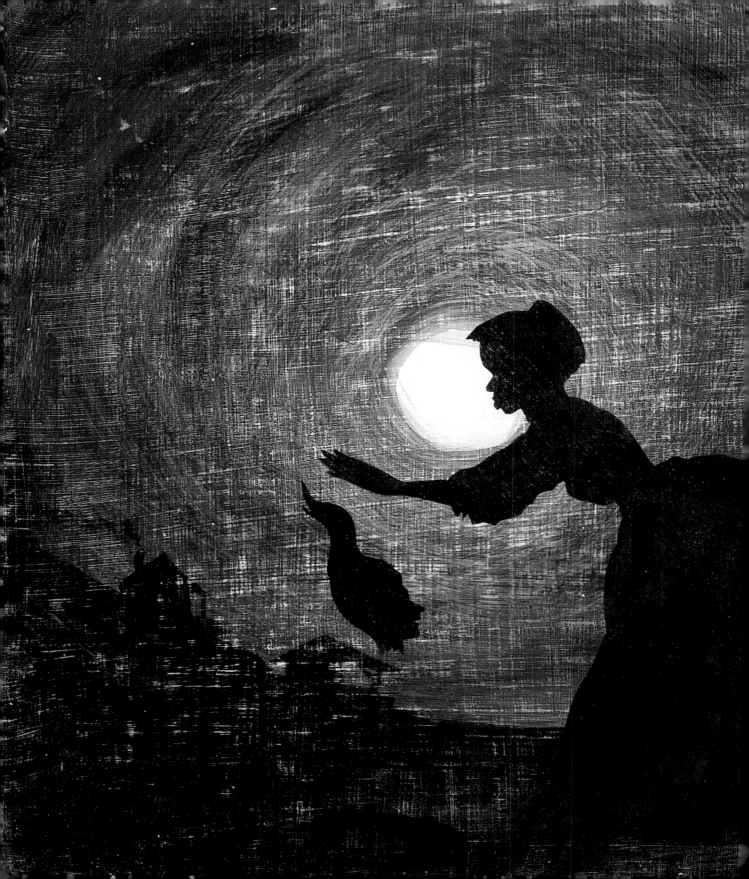

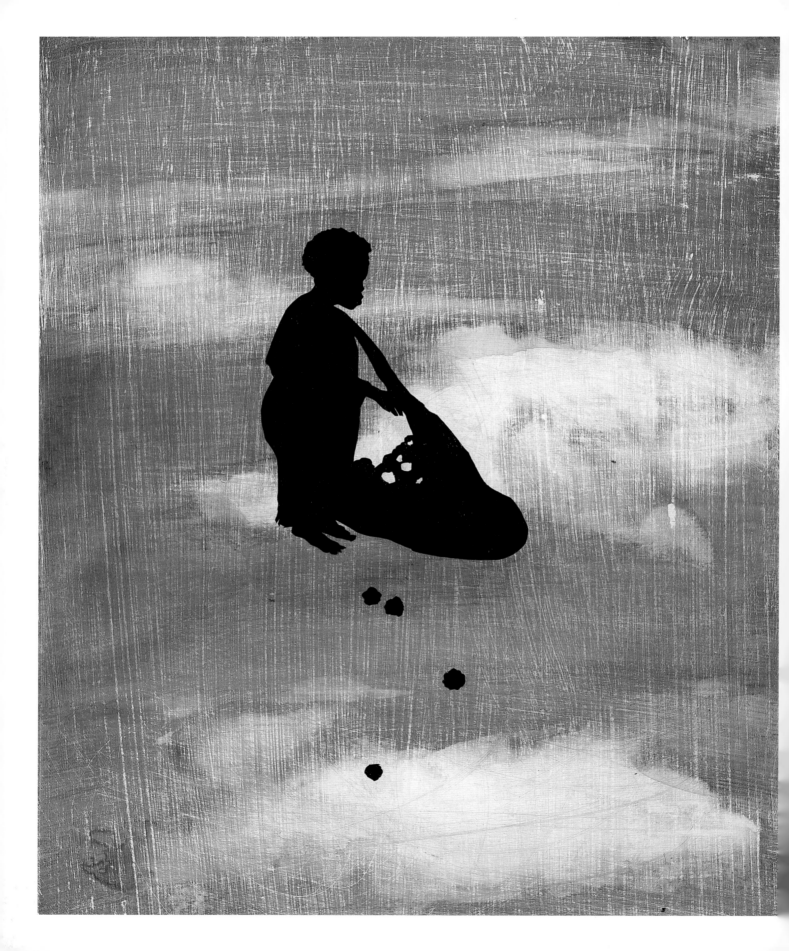

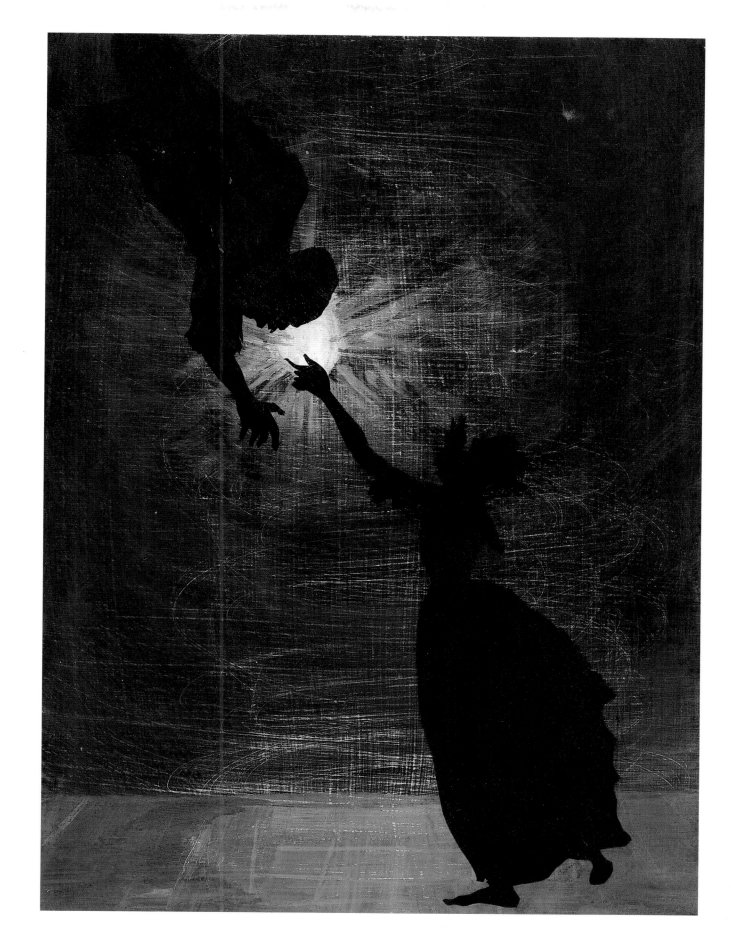

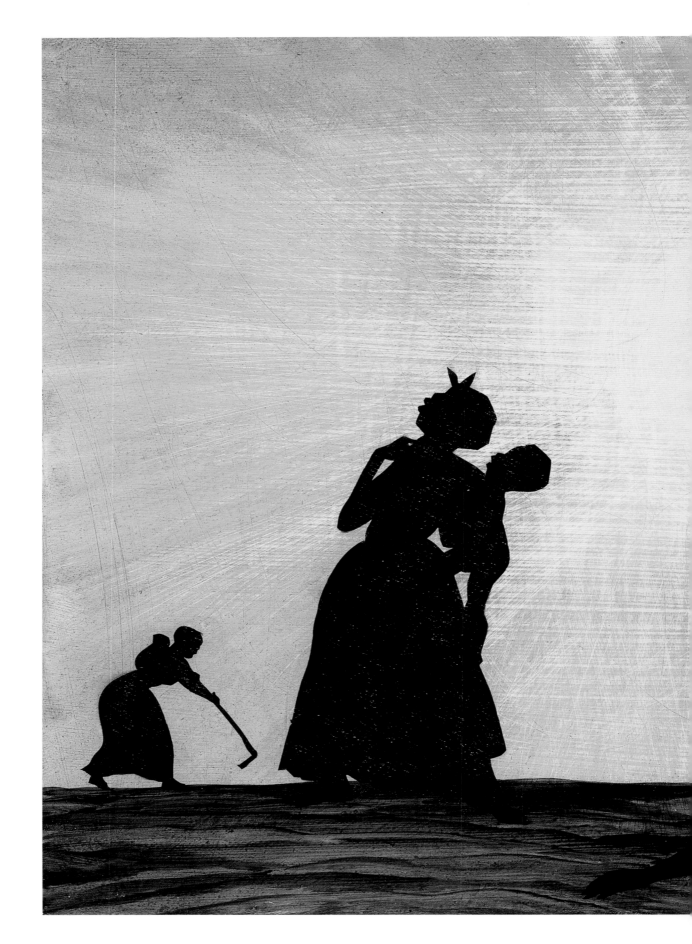

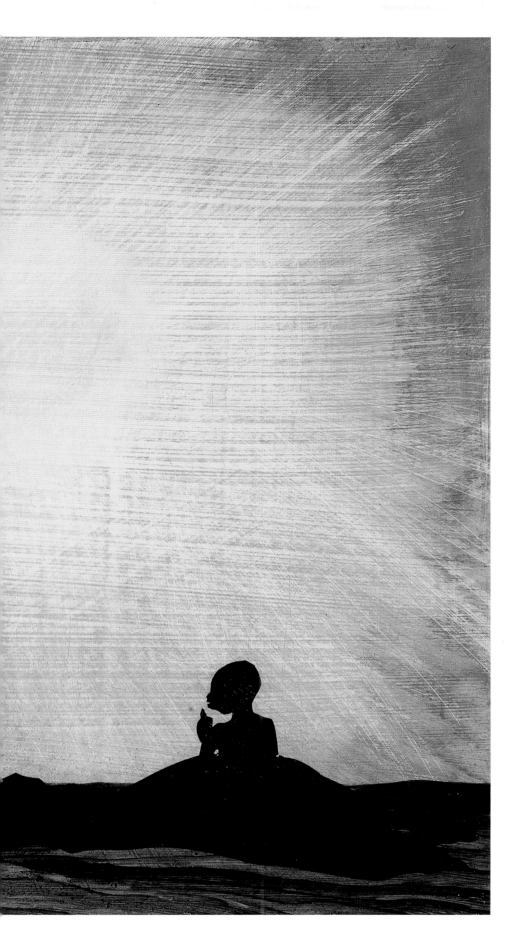

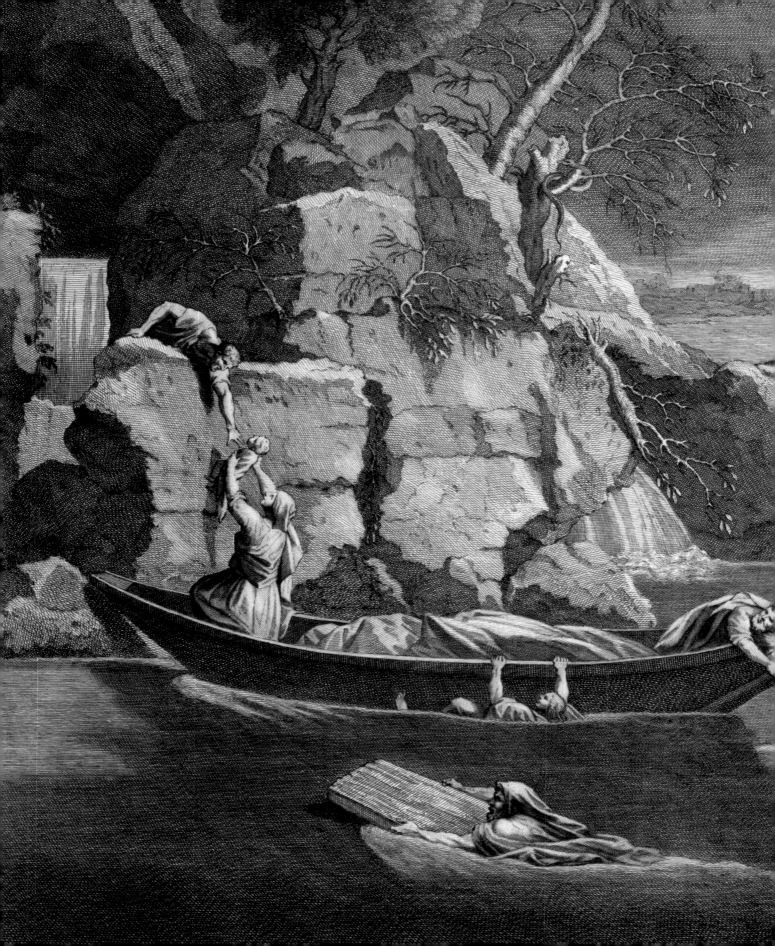

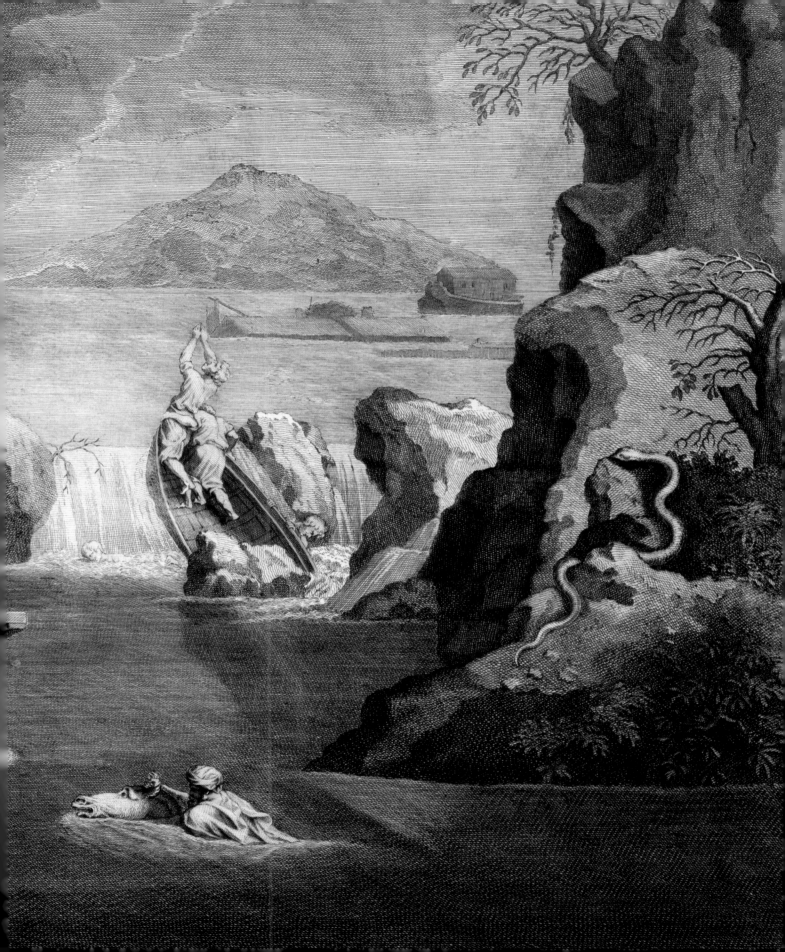

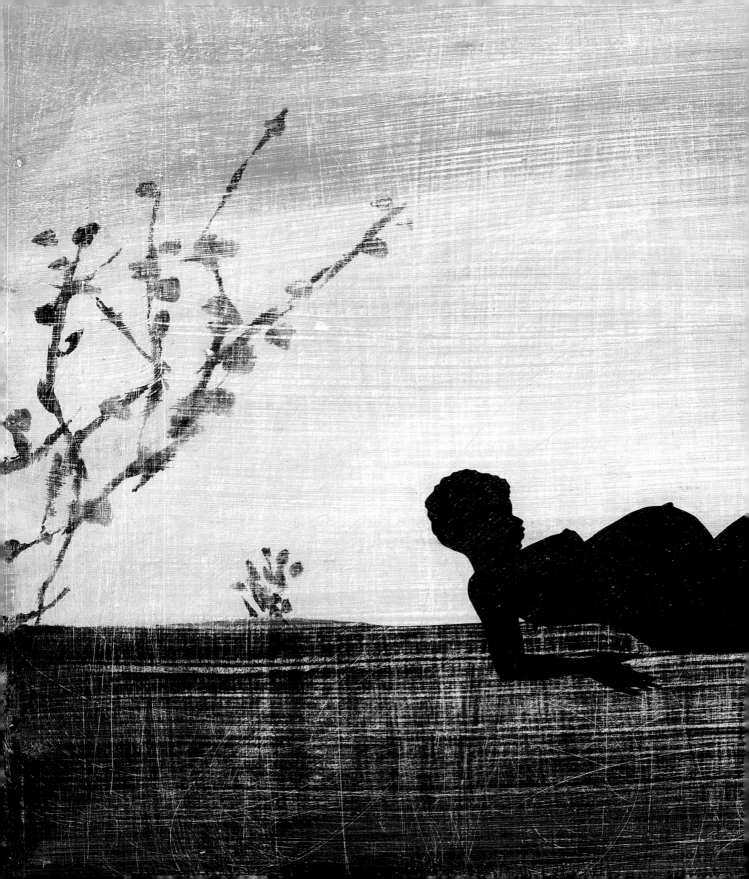

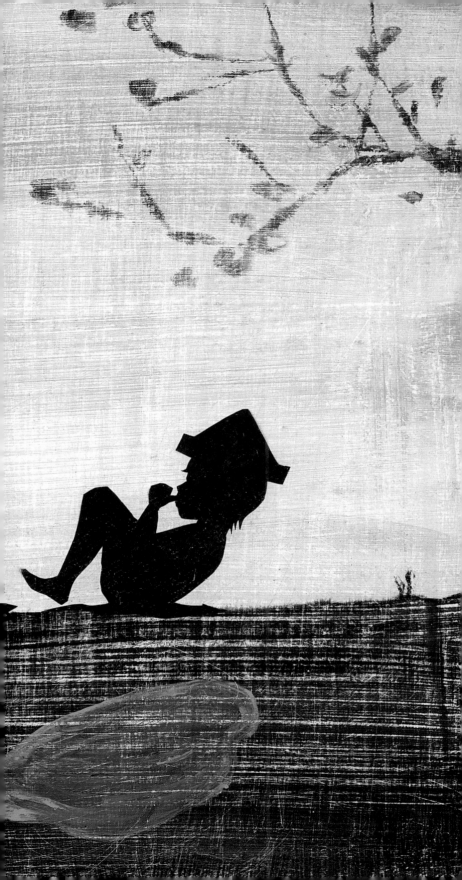

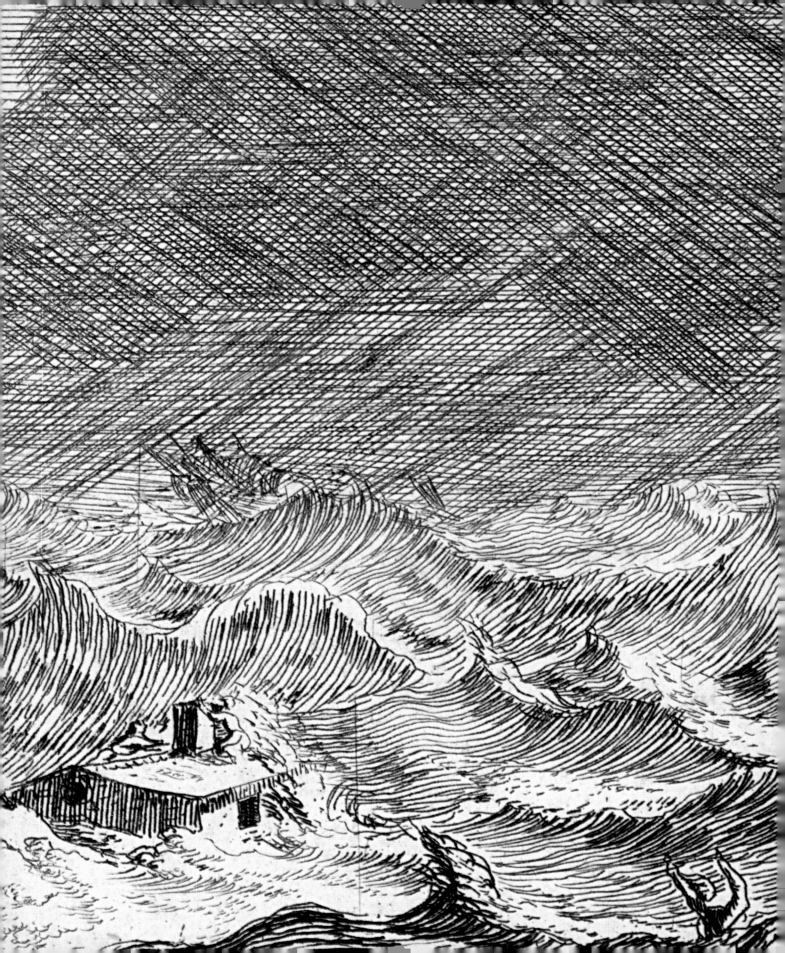

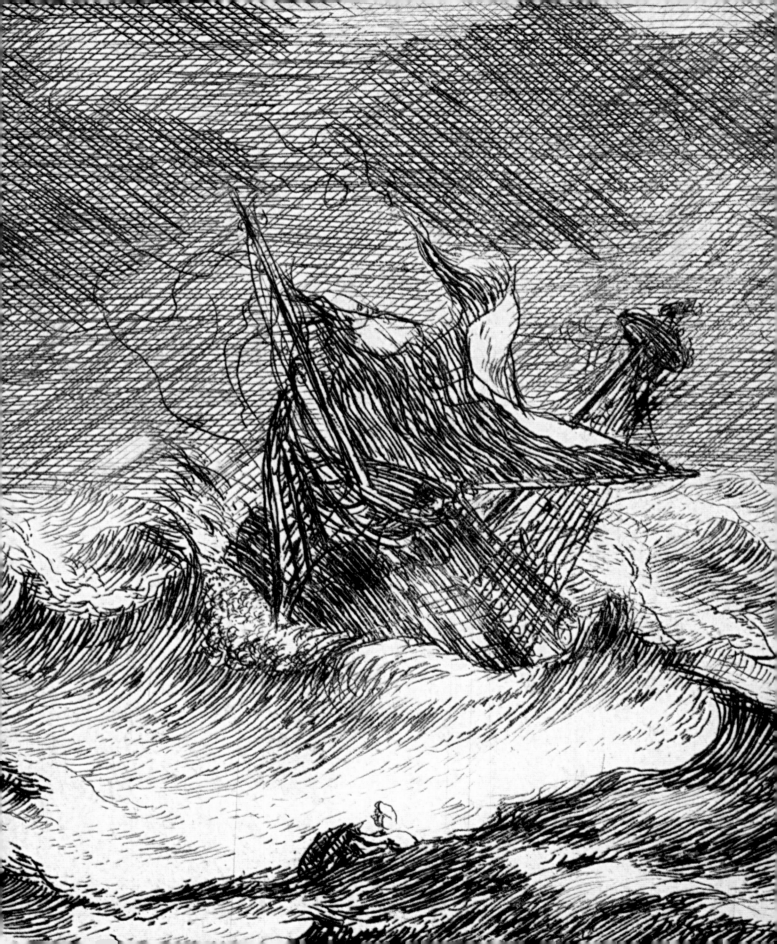

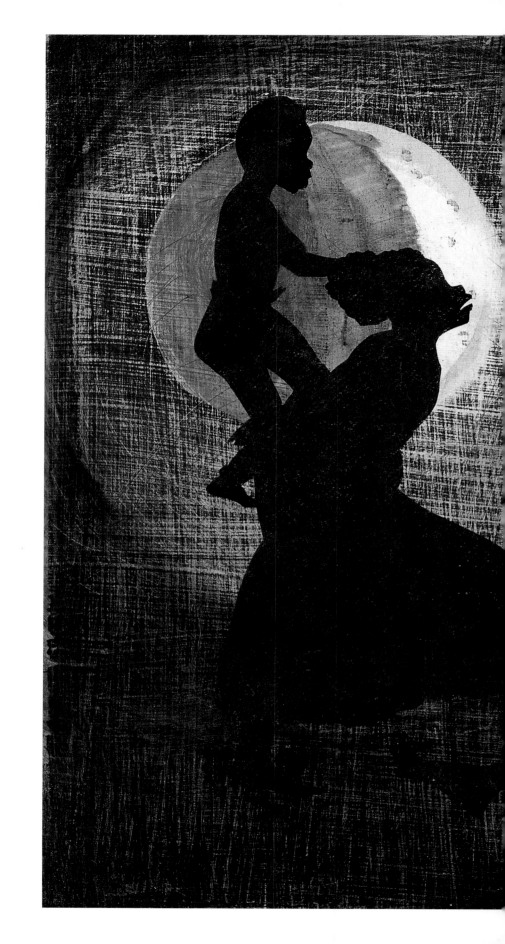

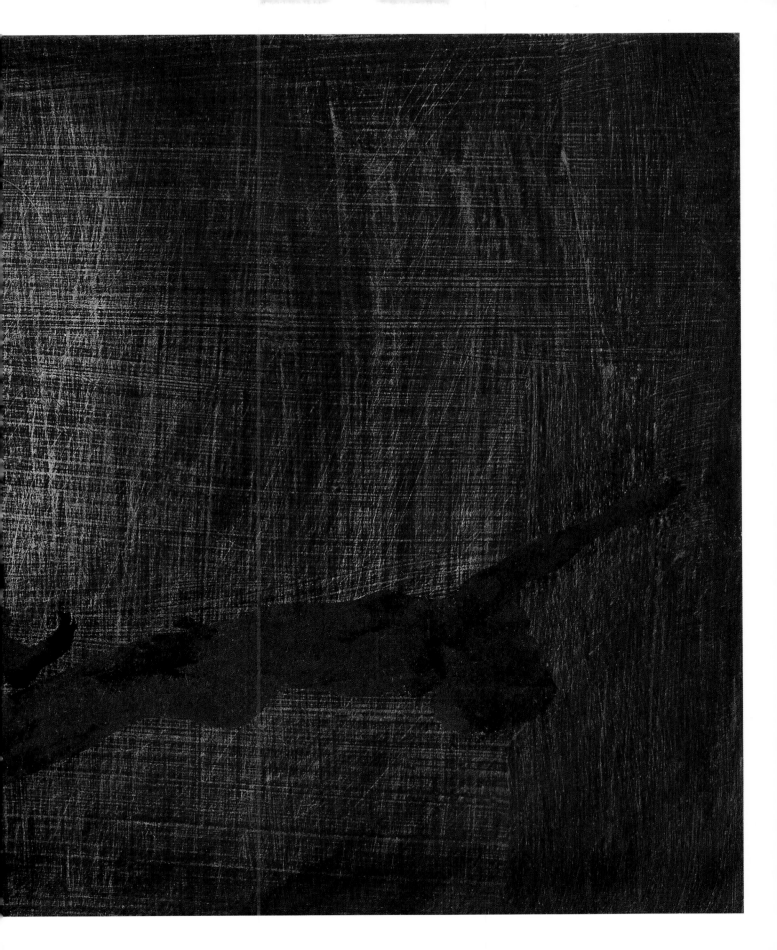

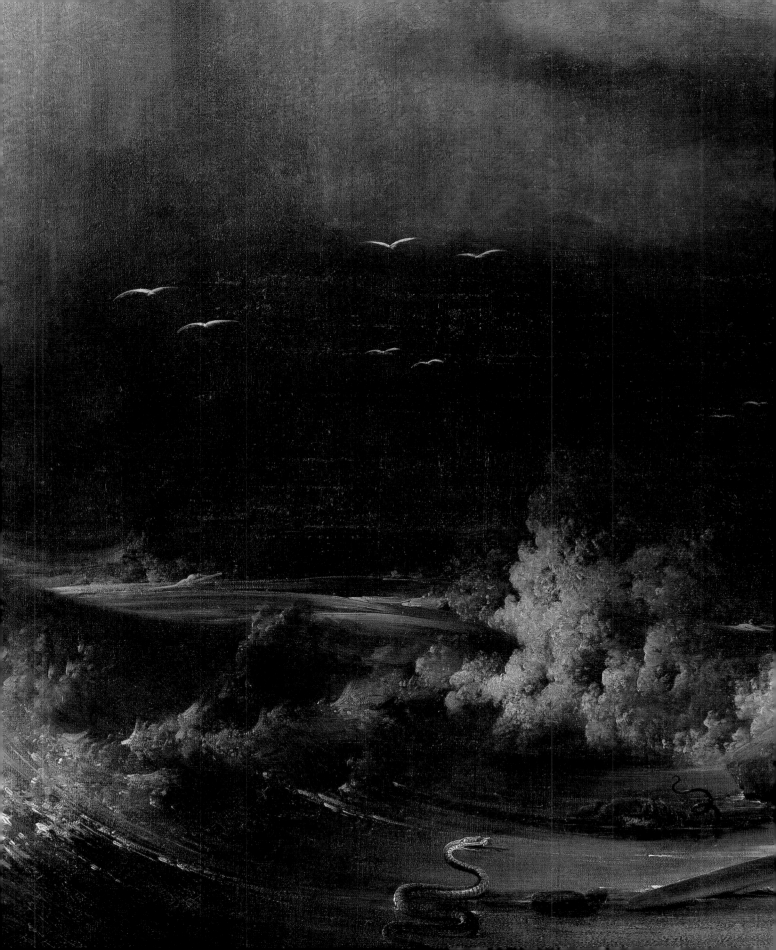

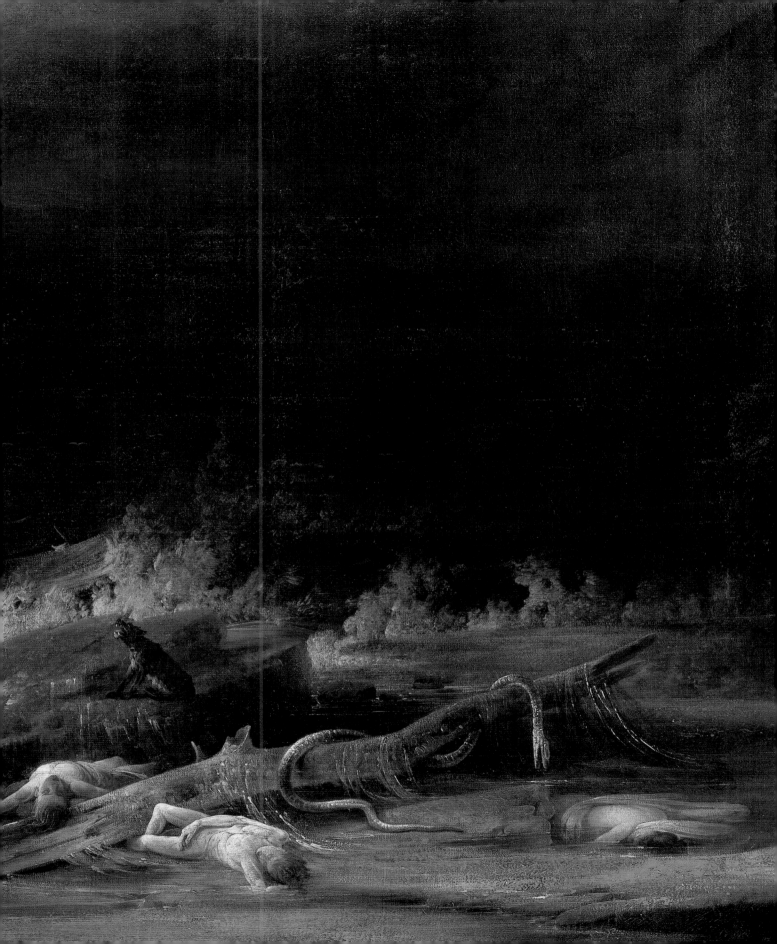

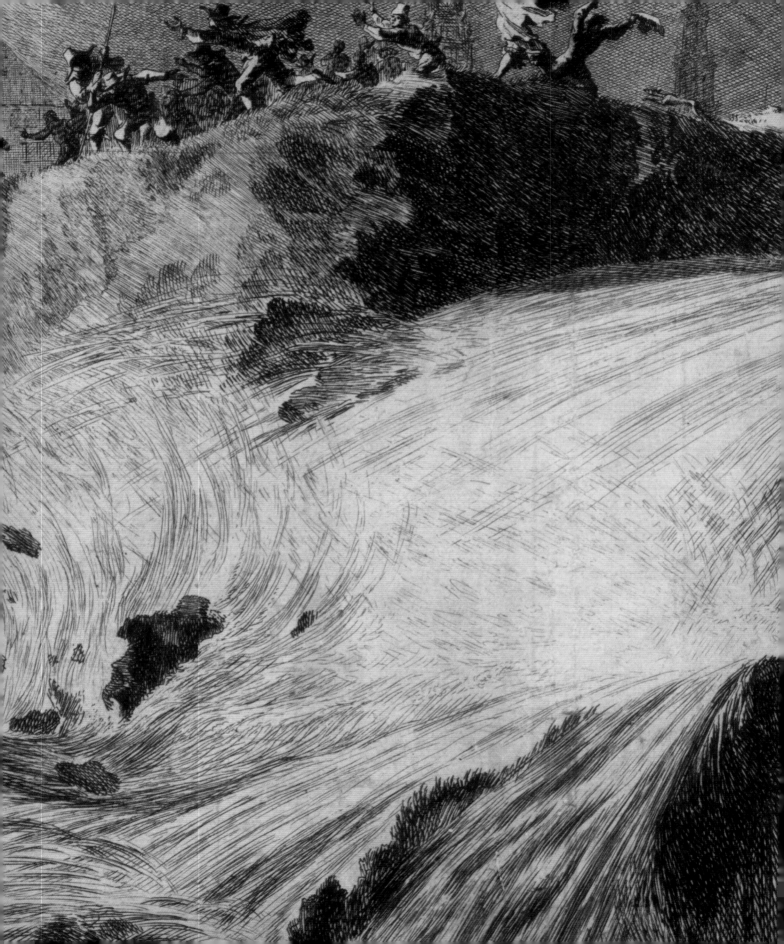

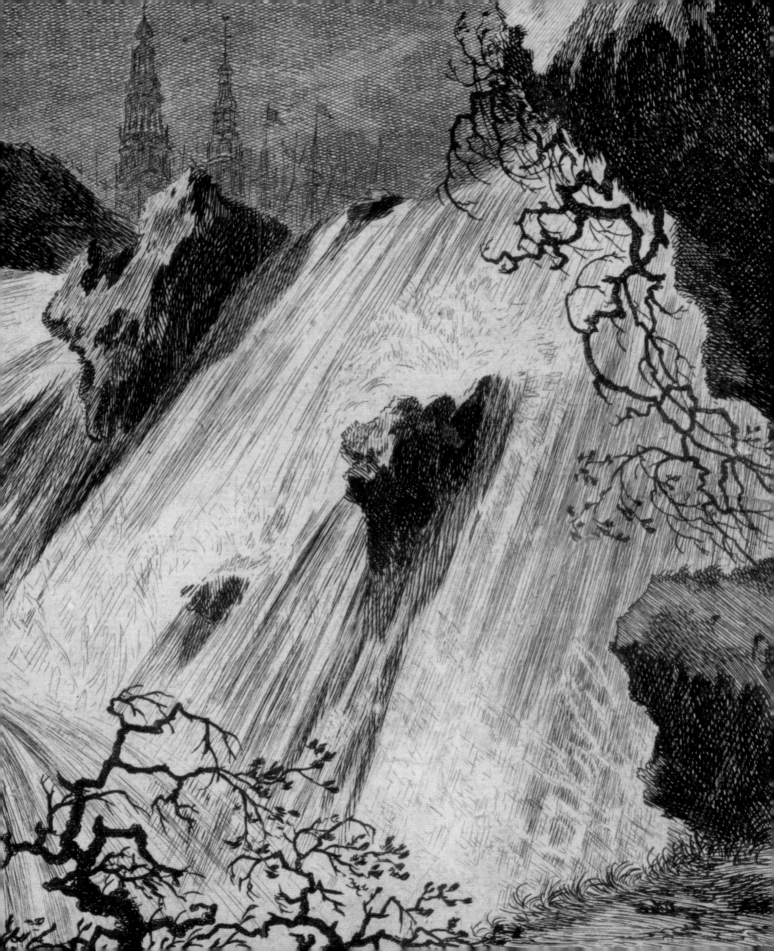

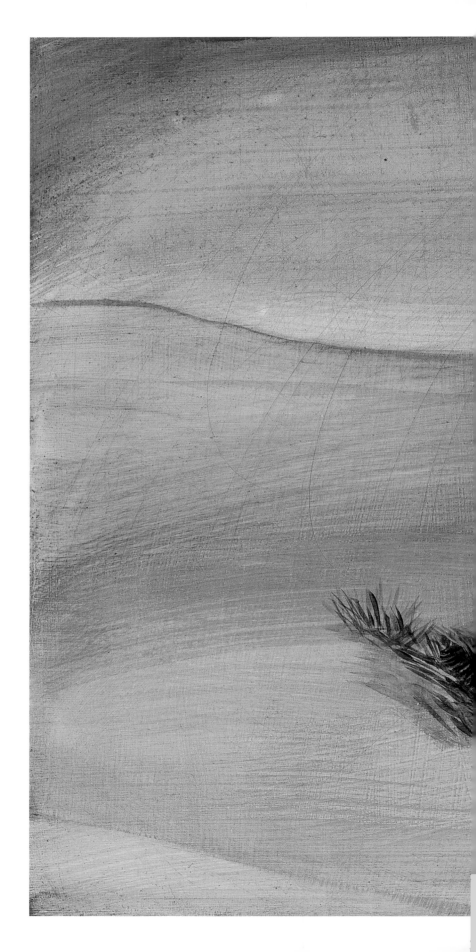

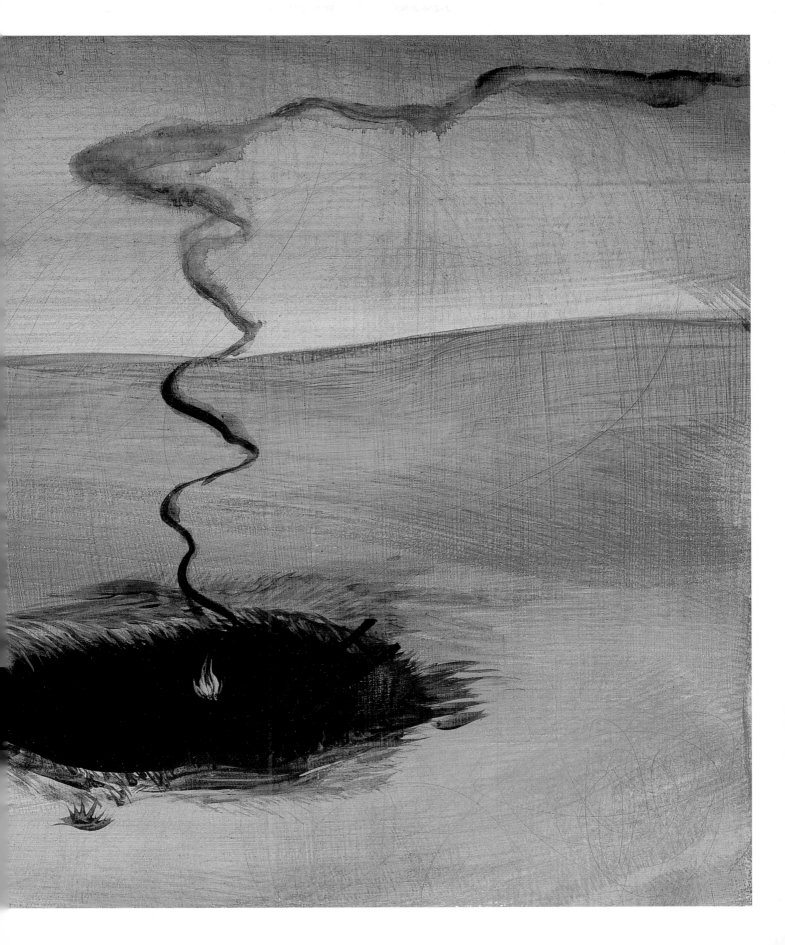

Years ago I entertained the fantasy of
my twin and I, my Good, evil twin, the
one who doesn't exactly exist but
manifests in the form of new friends- friends
My twin and I taking a Racist for a Run
 The Ultimate seductress,
causes a man to lose his belief, to lose his
faith in himself, his laws and what better
justified seduction could there be?
the Sexual Sacrafice- Us colored
women suffer this delusion of Grand
martyrdom. Becoming new chirsts
 Christs

Our Mother's would Kill us.

Beauty of it is, we don't perish at his
limp and weary hand.
Beauty of it is, we don't kill him either,
no explosions,
no irrepairable wounds,
We fly off intothe Night (from whence we
came) Dark Alabama Klansman night
leaving exposed and Salivating
David Duke in his Bureau, tied a bit,
panting. We leave beauty in
our
departure.

Our fathers would die.

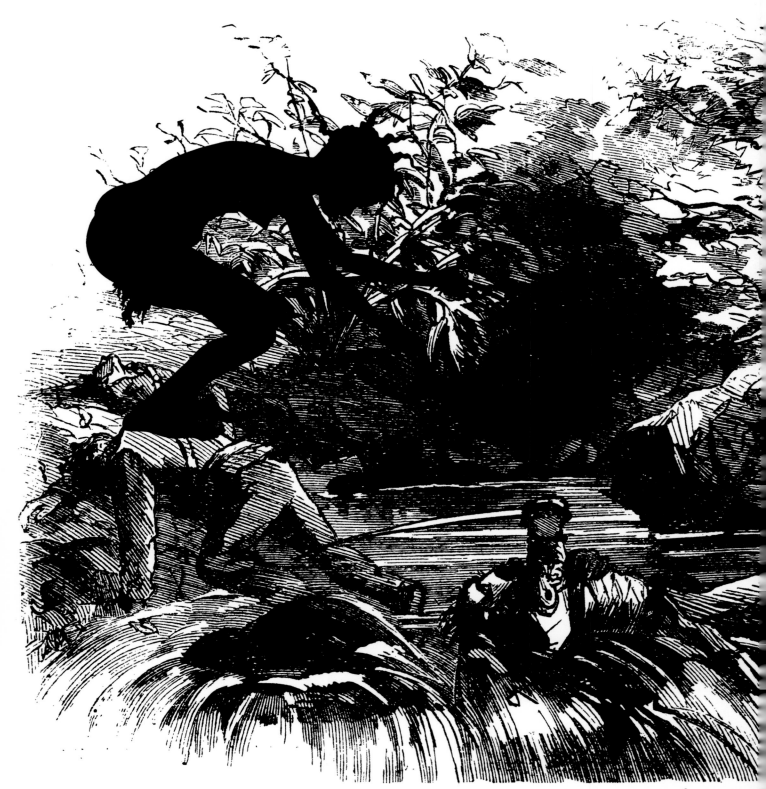

DEADBROOK AFTER THE BATTLE OF EZRA'S CHURC

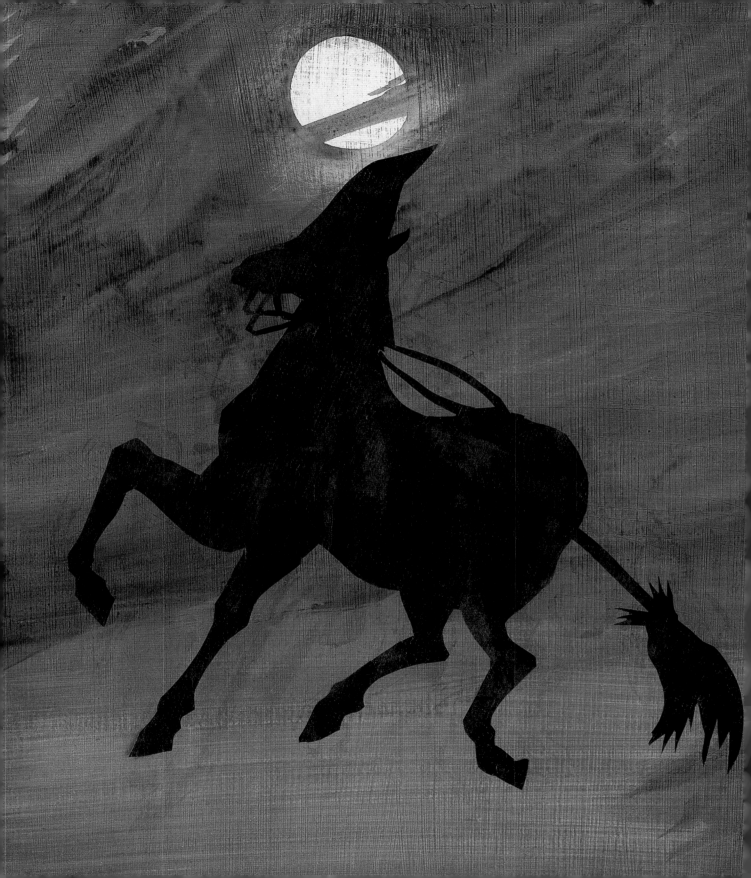

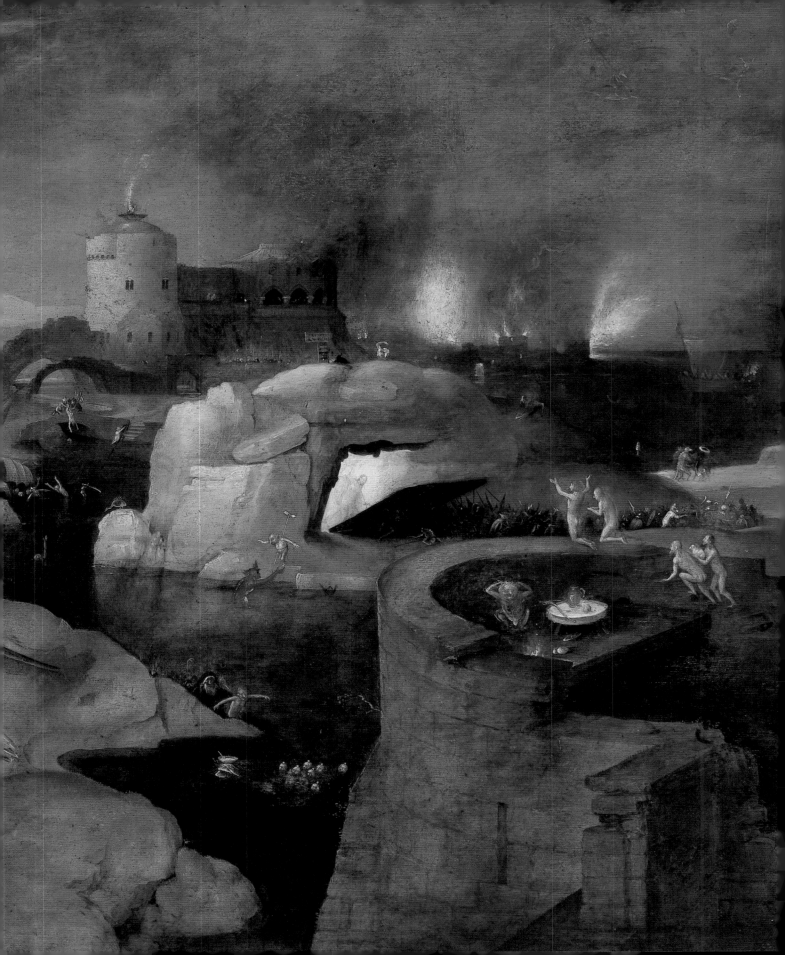

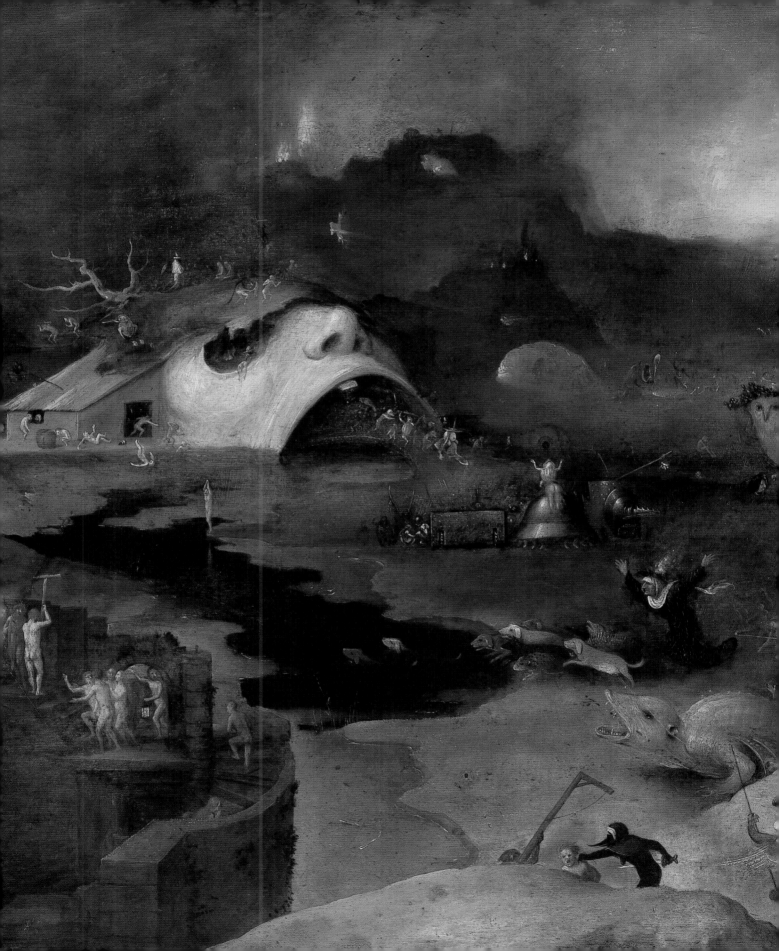

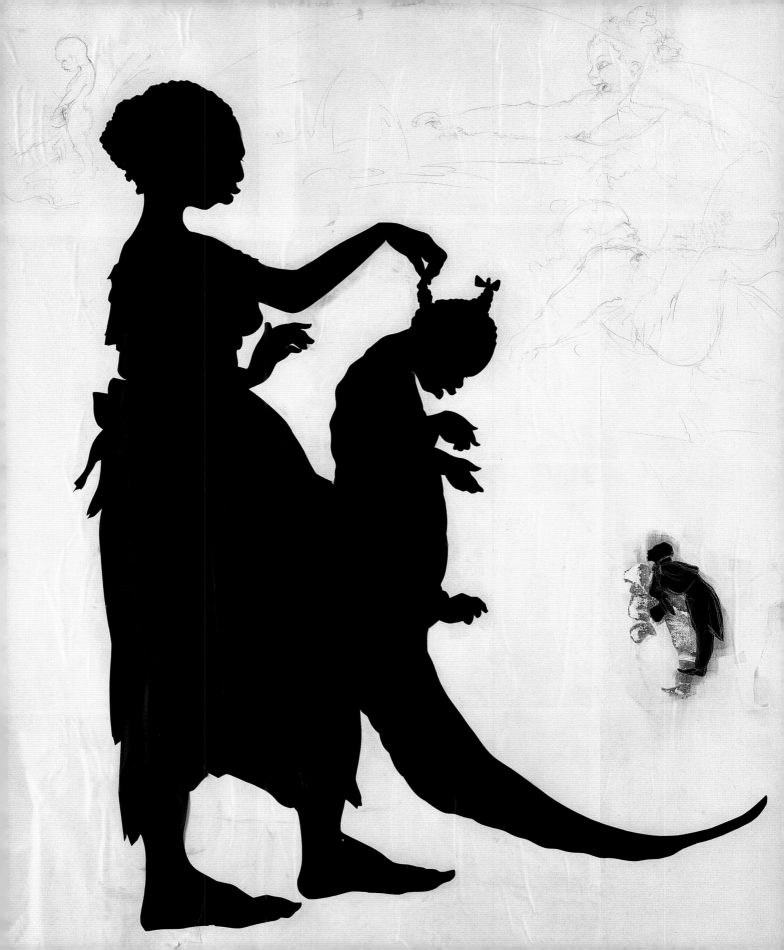

 Constructive criticism for
plantation Lords.

 watch out.

You never know where that "Last Dance" may
lead. Swift kick in the skull? Bashed and
bloodied nose? Pants around the ankles and
comic-sketch castration... Me and my
Wildly Grinning Negroes?

Sometimes it happens like this.

But not often.

Because We are Civil. Civilly Disobedient.

We nobly persuade our sons and daughters
to turn the other cheek (against firehoses)
and to RISE UP! rise above massas
grimy, filth stained imagination... the
Genius of the KKK,the Pornographic Horror
of the American Lynchmob...

and still we "Rise" RISE RISE!

RISE RISE RISE RISE And still more...

We Rise most nearly out of our own Humanity
transforming in mid air into Angels and
Centaurs and Aborigals with wings... Clear
out of Earths orbit...

Where we meet our Comrades-in-Arms, those
Abolitionists and Marxists and Hippies, those
straggly white folk who neatly usher us
down again. Down we drift through clouds and
weather

And We are reintroduced to a world made New
by our Transcendence. Made new. We, US,
we upped the Ante on collective change.

Now Our enemies will fight using our tools.

And our Friends will Acquiesce in Fear.

Down we drift, into a world made New,
our Sons, Daughters float feetfirst into
new classrooms, behind new desks with
new curriculums

And we will Break bread together and pray
together and let bygones be bygones be bygones

(the floors are sticky in those classrooms...)

Our daughers return with a headful of
multiculturalism... Hey, it's not just your
culture we'll celebrate now, its all your
forgotten bretheren- Unite! and Our Sons
less, easily persuaded, Inheritors of a
malignant fear... Princes of shamed and
degraded castles (with turrets trussed)
sought revenge early on...

Sons:
Who despised their Fathers for self-imposed
emmasculation-(read: assimilation)
and who were taught the same.

Sons:
Like caged madmen, chewing off their feet to
escape the chains.

Brothers:
Choking on swallowed vengence
and Vomiting same

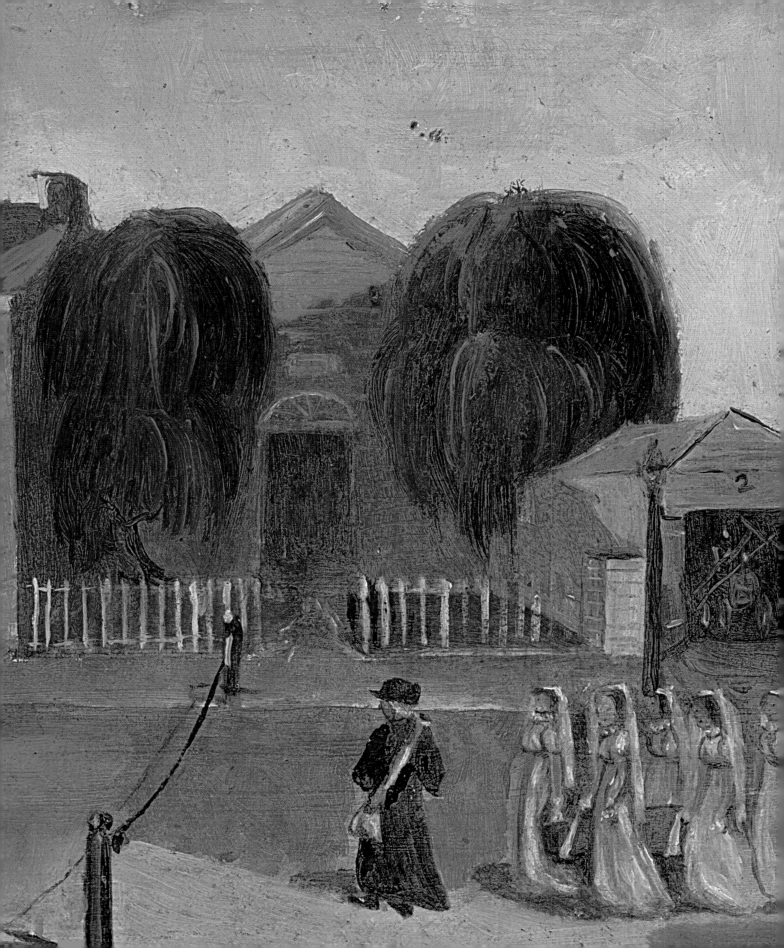

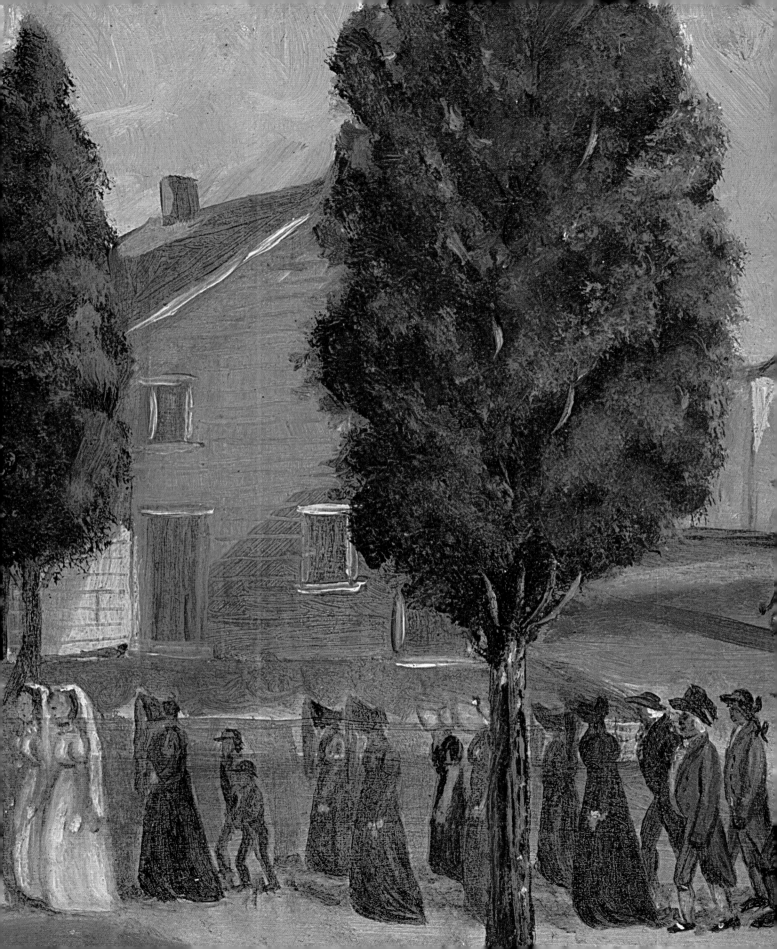

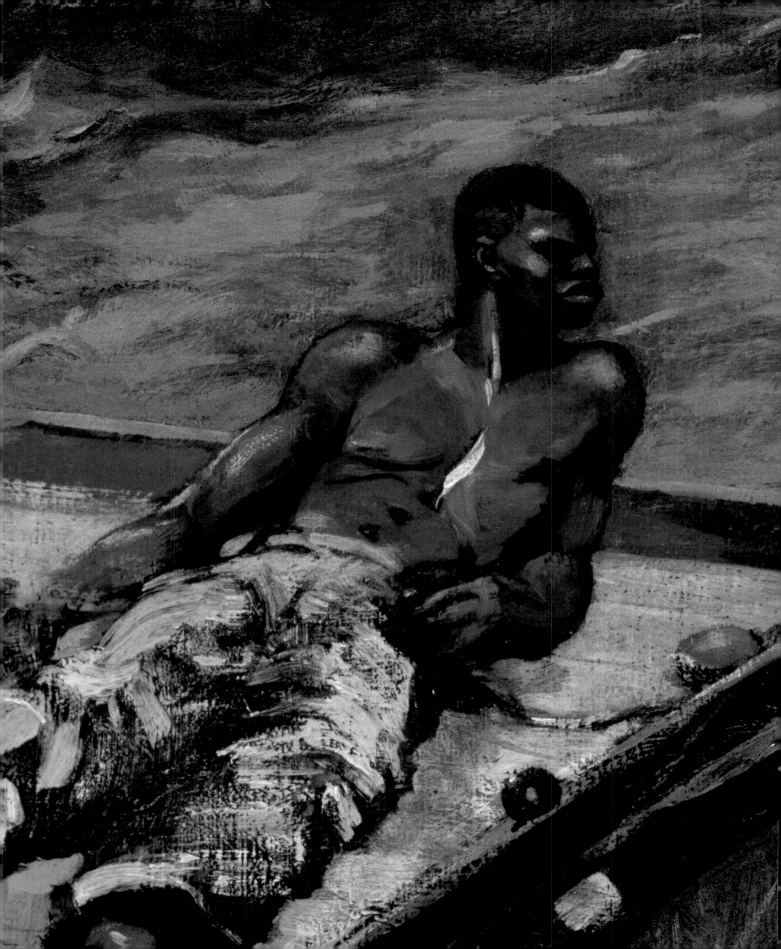

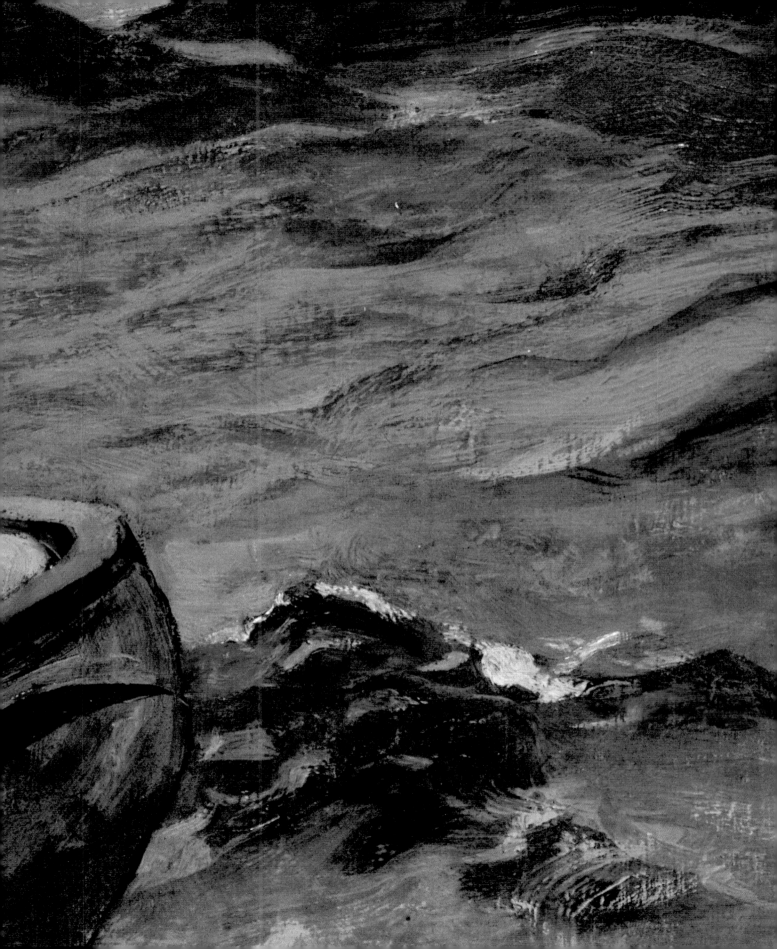

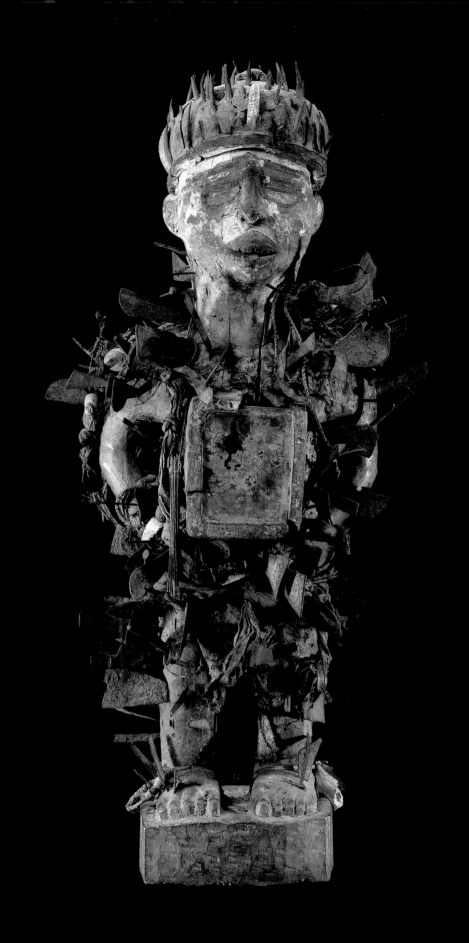

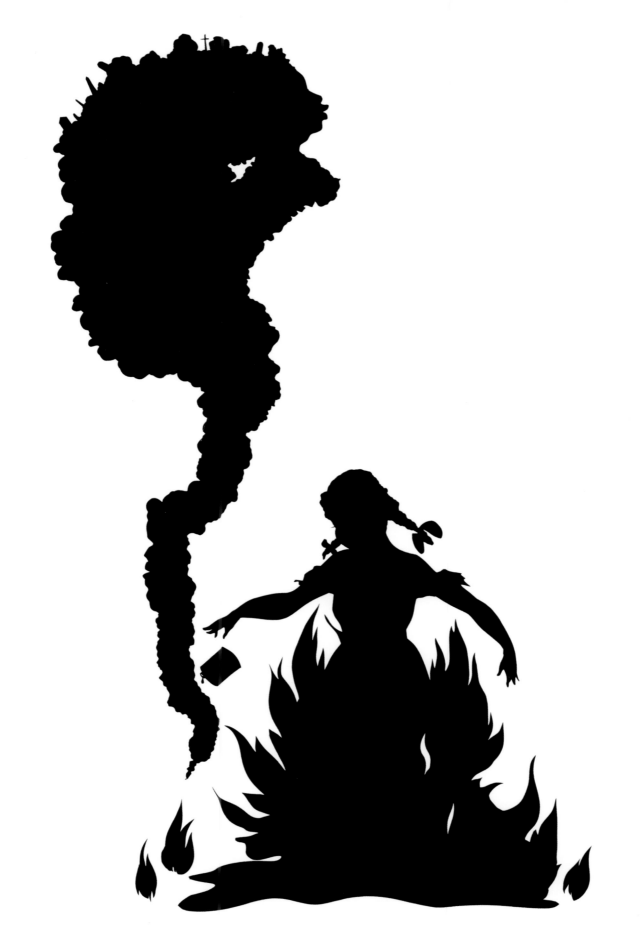

Index of Artworks

All works by Kara Walker were photographed by
Erma Estwick and are courtesy Sikkema Jenkins & Co.

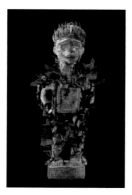

Unknown artist. *Male Power Figure (Nkisi)*, 19th century. Democratic Republic of Congo or Angola; Kongo peoples. Wood, iron, glass, terracotta, shells, cloth, fiber, pigment, seeds, beads. 28½ x 13 inches (72.4 x 33.03 cm). The Metropolitan Museum of Art. The Muriel Kallis Steinberg Newman Collection, Gift of Muriel Kallis Newman, in honor of Douglas Newton, 1990 (1990.334). Photograph © 1980 The Metropolitan Museum of Art
PAGE 2

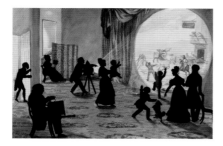

Auguste Edouart (French, 1789–1861). *Magic Lantern*. Cut paper and wash. Image: 9½ x 13⅜ inches (24.2 x 33.9 cm); sheet: 10¼ x 13½ inches (26 x 34.3 cm). The Metropolitan Museum of Art. Bequest of Mary Martin, 1938 (38.145.392). Image © 2006 The Metropolitan Museum of Art
PAGE 4

```
Perhaps Now is the time to
do
away with
pictures of
things
which
engage
our
pleasure
centers,
before
trying to
destroy
them
```

Kara Walker. *Untitled* from the series *American Primitives*, 2001. Typewriting on index card. Series of 36 plus 8 framed text panels. 3 x 5 inches (7.62 x 12.7 cm). Collection of Rachel and Jean-Pierre Lehmann
PAGE 5

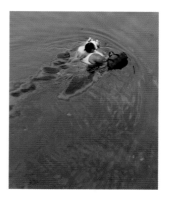

AP Images/Bill Haber
PAGE 8

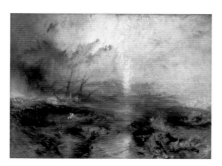

Joseph Mallord William Turner (English, 1775–1851). *Slave Ship (Slavers Throwing Overboard the Dead and Dying, Typhoon Coming On)*, 1840. Oil on canvas. 35¾ x 48¼ inches (90.8 x 122.6 cm). Museum of Fine Arts, Boston. Henry Lillie Pierce Fun, 99.22. Photography © 2007 Museum of Fine Arts, Boston
PAGES 10–11, DETAIL

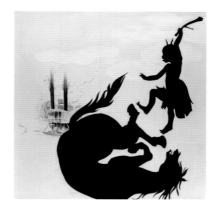

Kara Walker. *Untitled*, 1996. Cut paper and pastel on paper mounted on canvas. 69½ x 69½ inches (176.5 x 176.5 cm). Collection of Ninah and Michael Lynne
PAGE 13

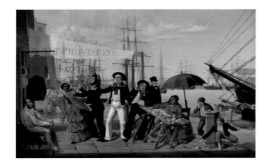

John Carlin (American, 1813–1891). *After a Long Cruise*, 1857. Oil on canvas. 20 x 30 inches (50.8 x 76.2 cm). The Metropolitan Museum of Art. Maria DeWitt Jesup Fund, 1949 (49.126). Photograph © 1999 The Metropolitan Museum of Art
PAGES 14–15

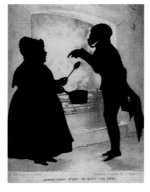

Auguste Edouart (French, 1789–1861). *A Treatise on Silhouette Likenesses*, 1835. Published by Longman & Co., London. Lithography. Overall: 9 x 5¹¹⁄₁₆ x ¹¹⁄₁₆ inches (22.8 x 14.5 x 1.8 cm). The Metropolitan Museum of Art. Bequest of Mary Martin, 1938 (38.145.570). Image © 2006 The Metropolitan Museum of Art
PAGE 21

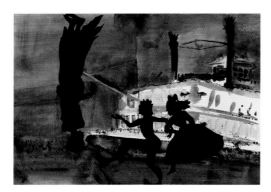

Kara Walker. *They Say Water Represents the Subconscious in Dreams* from the series *American Primitives*, 2001. Gouache and cut paper on paint board. Series of 36 plus 8 framed text panels. 8 x 11 inches (20.3 x 27.9 cm). Collection of Rachel and Jean-Pierre Lehmann
PAGES 16–17

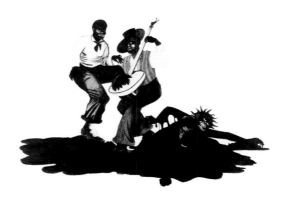

Kara Walker. *Untitled*, 2002. Graphite on paper. 65 x 70 inches (165.1 x 177.8 cm). Brooklyn Museum. Alfred T. White Fund 2003.15
PAGES 22–23

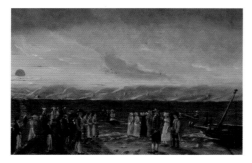

William P. Chappel (American, ca. 1800–1880). *Baptism*, 1870s. Oil on slate paper. 6⅛ x 9¼ inches (15.6 x 23.5 cm). The Metropolitan Museum of Art. The Edward W. C. Arnold Collection of New York Prints, Maps, and Pictures, Bequest of Edward W. C. Arnold, 1954 (54.90.515). Image © 2006 The Metropolitan Museum of Art
PAGES 18–19

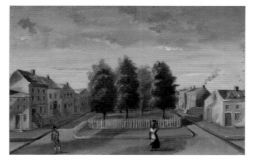

William P. Chappel (American, ca. 1800–1880). *Baked Pears in Duane Park*, 1870s. Oil on slate paper. 6 x 9⅛ inches (15.2 x 23.2 cm). The Metropolitan Museum of Art. The Edward W. C. Arnold Collection of New York Prints, Maps, and Pictures, Bequest of Edward W. C. Arnold, 1954 (54.90. 494). Image © 2006 The Metropolitan Museum of Art
PAGES 24–25

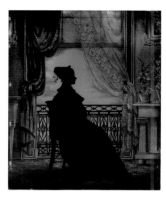

Attributed to William Henry Brown (American,
1808–1882). *Portrait of a Woman before a Window*, before
1860. Cut paper with lithographic background. Sheet:
14½ x 12 inches (36.8 x 30.5 cm). The Metropolitan
Museum of Art. Mary Martin Fund, 1984 (1984.1101.1).
Image © 2006 The Metropolitan Museum of Art
PAGE 26

William P. Chappel (American, ca. 1800–1880). *The
Boot Black*, 1870s. Oil on slate paper. 6¹⁄₁₆ x 9⅛ inches
(15.4 x 23.2 cm). The Metropolitan Museum of Art. The
Edward W. C. Arnold Collection of New York Prints,
Maps, and Pictures, Bequest of Edward W. C. Arnold,
1954 (54.90.501). Image © 2006 The Metropolitan
Museum of Art
PAGES 28–29

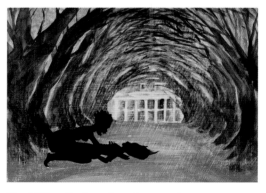

Kara Walker. *Big House* from the series *American
Primitives*, 2001. Gouache and cut paper on paint board.
Series of 36 plus 8 framed text panels. 8 x 11 inches (20.3 x
27.9 cm). Collection of Rachel and Jean-Pierre Lehmann
PAGES 30–31

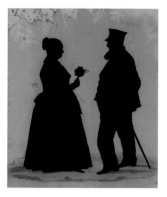

Anonymous (American, 19th century). *An Old Man and
Woman*. Cut paper with wash. Sheet: 14 x 12 inches
(35.5 x 30.5 cm). The Metropolitan Museum of Art.
Bequest of Mary Martin, 1938 (38.145.339). Image © 2006
The Metropolitan Museum of Art
PAGE 32

Dear Cruel and malevolent Master,

What irks me, you know this, is that I am·
and forever shall be a slave to that which
~~brought~~ ~~(said)~~ "brung"₄ me here.

And while I know that the better part of me
understands - um- that thing you say
that-
I am more than just a product of black history
or American history, or Womens Liberation...

Kara Walker. *Untitled* from the series *American Primitives*,
2001. Typewriting on index cards. Series of 36 plus 8
framed text panels. Each card 3 x 5 inches (7.62 x 12.7 cm).
Collection of Rachel and Jean-Pierre Lehmann
PAGES 33–35

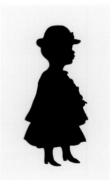

Anonymous (American, 19th–20th centuries). *A Small
Girl with Cape and Hat*. Cut paper. Image: 5⅞ x 2⁹⁄₁₆ inches
(15 x 6.5 cm); sheet: 12³⁄₁₆ x 7¹¹⁄₁₆ inches (31 x 19.5 cm). The
Metropolitan Museum of Art. Museum accession 1942
(X.792). Image © 2006 The Metropolitan Museum of Art
PAGE 36

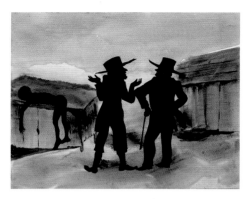

Kara Walker. *Beats Me* from the series *American Primitives*, 2001. Gouache and cut paper on paint board. Series of 36 plus 8 framed text panels. 8 x 10 inches (20.3 x 25.4 cm). Collection of Rachel and Jean-Pierre Lehmann
PAGE 37

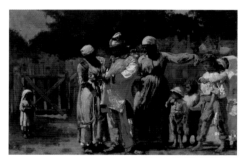

Winslow Homer (American, 1836–1910). *Dressing for the Carnival*, 1877. Oil on canvas. 20 x 30 inches (50.8 x 76.2 cm). The Metropolitan Museum of Art. Amelia B. Lazarus Fund, 1922 (22.220). Image © 2006 The Metropolitan Museum of Art
PAGES 38–39

```
      Like simon Legree, the bad man-
I is haunted by demons of my own devising

This leaves me vulnerable to the simple
threats of children and inferiors, who
tease the cracks in my walled fortress-like
reserve
```

Kara Walker. *Untitled* from the series *American Primitives*, 2001. Typewriting on index cards. Series of 36 plus 8 framed text panels. Each card 3 x 5 inches (7.62 x 12.7 cm). Collection of Rachel and Jean-Pierre Lehmann
PAGES 40–41

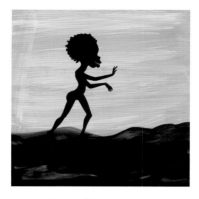

Kara Walker. *Middle Passages*, 2004. Gouache, cut paper, and collage on board. One from a series of 5. 17 x 17 inches (43.2 x 43.2 cm). Collection of Marc and Lisa Mills
PAGE 43

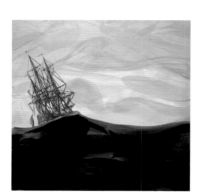

Kara Walker. *Middle Passages*, 2004. Gouache, cut paper, and collage on board. One from a series of 5. 15 x 15 inches (38.1 x 38.1 cm). Collection of Marc and Lisa Mills
PAGE 44

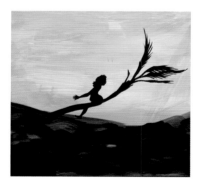

Kara Walker. *Middle Passages*, 2004. Gouache, cut paper, and collage on board. One from a series of 5. 15 x 15 inches (38.1 x 38.1 cm). Collection of Marc and Lisa Mills
PAGE 45

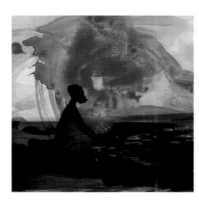

Kara Walker. *Middle Passages*, 2004. Gouache, cut paper, and collage on board. One from a series of 5. 15 x 15 inches (38.1 x 38.1 cm). Collection of Marc and Lisa Mills

PAGE 46

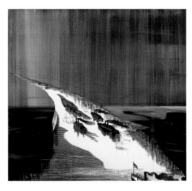

Kara Walker. *Middle Passages*, 2004. Gouache, cut paper, and collage on board. One from a series of 5. 17 x 17 inches (43.2 x 43.2 cm). Collection of Marc and Lisa Mills

PAGE 47

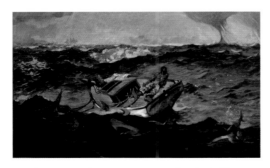

Winslow Homer (American, 1836–1910). *The Gulf Stream*, 1899. Oil on canvas. 28⅛ x 49⅛ inches (71.4 x 124.8 cm). The Metropolitan Museum of Art. Catharine Lorillard Wolfe Collection, Wolfe Fund, 1906 (06.1234). Image © 2006 The Metropolitan Museum of Art

PAGES 48–49

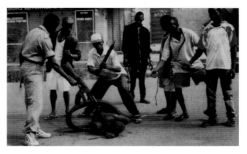

Kara Walker. *Untitled* from the series *American Primitives*, 2001. Found images. Series of 36 plus 8 framed text panels. Each panel 3 x 5 inches (7.62 x 12.7 cm). Collection of Rachel and Jean-Pierre Lehmann

PAGE 50

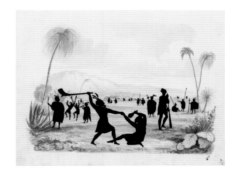

Auguste Edouart (French, 1789–1861). *South Sea Islanders*. Cut paper with wash. Sheet: 10⁷⁄₁₆ x 13⁷⁄₁₆ inches (26.5 x 34.2 cm). The Metropolitan Museum of Art. Bequest of Glenn Tilley Morse, 1950 (50.602.1377). Image © 2006 The Metropolitan Museum of Art

PAGE 51

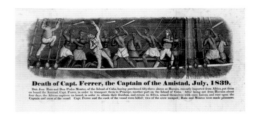

John Warner Barber (American, 1798–1885). *A History of the Amistad Captives: Being a Circumstantial Account of the Capture of the Spanish Schooner Amistad, by the Africans on Board; Their Voyage, and Capture near Long Island, New York; with Biographical Sketches of Each of the Surviving Africans* (frontispiece fold-out, title page, and page 12, respectively), 1840. Overall: 9⁷⁄₁₆ x 6⅛ inches (24 x 15.5 cm); sheet size of fold-out wood engraving: 9½ x 19¼ inches (24 x 49 cm). Wood engravings with hand-coloring and letterpress. The Metropolitan Museum of Art The Elisha Whittelsey Collection, The Elisha Whittelsey Fund, 1954 (54.509.80). Image © 2006 The Metropolitan Museum of Art

PAGES 52–54

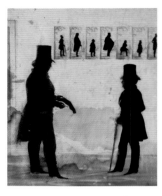

Anonymous (American, 19th century). *Two Men, one cutting a Silhouette.* Cut paper with wash. Sheet: 15¹³⁄₁₆ x 13¹⁄₁₆ inches (40.2 x 33.2 cm). The Metropolitan Museum of Art. Bequest of Glenn Tilley Morse, 1950 (50.602.143). Image © 2006 The Metropolitan Museum of Art
PAGE 55

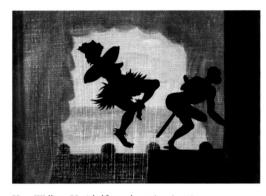

Kara Walker. *Untitled* from the series *American Primitives*, 2001. Gouache and cut paper on paint board. Series of 36 plus 8 framed text panels. 9 x 12 inches (22.9 x 30.5 cm). Collection of Rachel and Jean-Pierre Lehmann
PAGES 56–57

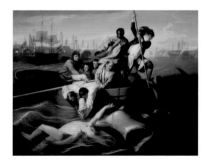

John Singleton Copley (American, 1738–1815). *Watson and the Shark*, 1778. Oil on canvas. 72¼ x 90⅜ inches (183.51 x 229.55 cm). Museum of Fine Arts, Boston. Gift of Mrs. George von Lengerke Meyer, 89.481. Photography © 2007 Museum of Fine Arts, Boston
PAGES 58–59

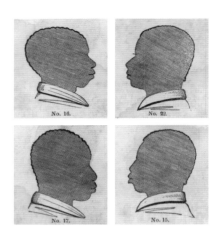

John Warner Barber (American, 1798–1885). *A History of the Amistad Captives: Being a Circumstantial Account of the Capture of the Spanish Schooner Amistad, by the Africans on Board; Their Voyage, and Capture near Long Island, New York; with Biographical Sketches of Each of the Surviving Africans* (details from pages 12–13), 1840 (see entry on page 113 for complete caption)
PAGE 60

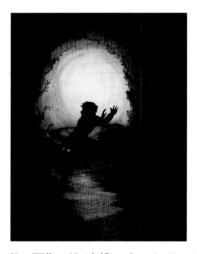

Kara Walker. *Untitled* from the series *American Primitives*, 2001. Gouache and cut paper on paint board. Series of 36 plus 8 framed text panels. 11 x 8 inches (27.9 x 20.3 cm). Collection of Rachel and Jean-Pierre Lehmann
PAGE 61

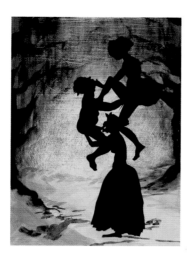

Kara Walker. *Untitled* from the series *American Primitives*, 2001. Gouache and cut paper on paint board. Series of 36 plus 8 framed text panels. 11 x 8 inches (27.9 x 20.3 cm). Collection of Rachel and Jean-Pierre Lehmann
PAGE 63

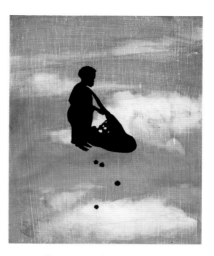

Kara Walker. *Ancestor* from the series *American Primitives*, 2001. Gouache and cut paper on paint board. Series of 36 plus 8 framed text panels. 11 x 8 inches (27.9 x 20.3 cm). Collection of Rachel and Jean-Pierre Lehmann
PAGE 66

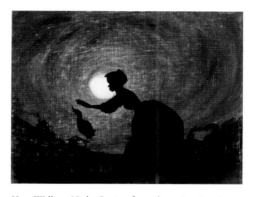

Kara Walker. *Night Conjure* from the series *American Primitives*, 2001. Gouache and cut paper on paint board. Series of 36 plus 8 framed text panels. 8 x 10 inches (20.3 x 25.4 cm). Collection of Rachel and Jean-Pierre Lehmann
PAGES 64–65

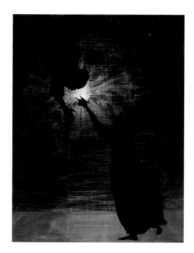

Kara Walker. *The Negro Muse Misses His Mark (Again)* from the series *American Primitives*, 2001. Gouache and cut paper on paint board. Series of 36 plus 8 framed text panels. 11 x 8 inches (27.9 x 20.3 cm). Collection of Rachel and Jean-Pierre Lehmann
PAGE 67

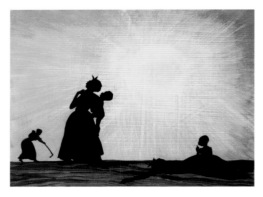

Kara Walker. *Trilogy* from the series *American Primitives*, 2001. Gouache and cut paper on paint board. Series of 36 plus 8 framed text panels. 9 x 12 inches (22.9 x 30.5 cm). Collection of Rachel and Jean-Pierre Lehmann
PAGES 68–69

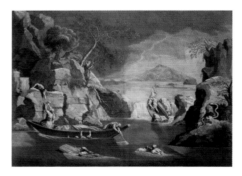

Jean Audran (French, 1667–1756) after Nicholas Poussin (French, 1594–1665). *The Flood* (*Winter*). Engraving 18⁷⁄₁₆ x 23¹¹⁄₁₆ inches (46.8 x 60.2 cm). The Metropolitan Museum of Art. Harris Brisbane Dick Fund, 1953 (53.600.1162). Image © 2006 The Metropolitan Museum of Art
PAGES 72–73, DETAIL

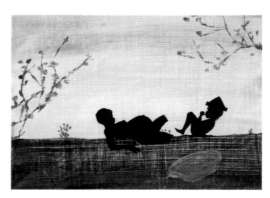

Kara Walker. *Lands Cave* from the series *American Primitives*, 2001. Gouache and cut paper on paint board. Series of 36 plus 8 framed text panels. 8 x 11 inches (20.3 x 27.9 cm). Collection of Rachel and Jean-Pierre Lehmann

PAGES 74–75

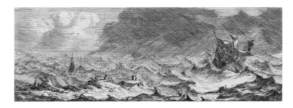

Reynier Nooms Zeeman (Dutch, 1623–ca. 1663). *Water from series Four Elements* (ca. 1651–52). Etching. Sheet: 2¹⁵⁄₁₆ x 7¹⁵⁄₁₆ inches (7.5 x 20.2 cm). The Metropolitan Museum of Art. Bequest of Grace M. Pugh, 1985 (1986.1180.1412). Image © 2006 The Metropolitan Museum of Art
PAGES 76–77, DETAIL

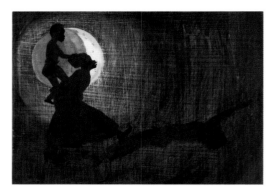

Kara Walker. *Revised Trajectory* from the series *American Primitives*, 2001. Gouache and cut paper on paint board. Series of 36 plus 8 framed text panels. 8 x 11 inches (20.3 x 27.9 cm). Collection of Rachel and Jean-Pierre Lehmann
PAGES 78–79

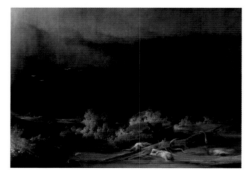

Joshua Shaw (American, ca. 1777–1860). *The Deluge towards Its Close*, ca. 1813. Oil on canvas. 48¼ x 66 inches (122.6 x 167.6 cm). The Metropolitan Museum of Art. Gift of William Merritt Chase, 1909 (09.14). Photograph © 1981 The Metropolitan Museum of Art
PAGES 80–81, DETAIL

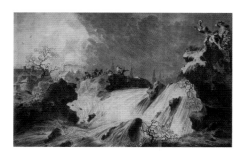

Pieter Nolpe (Dutch, ca. 1614–1653). *The Bursting of St. Anthony's Dike, 5 March 1651. Vertoninge . . . Amsterdam.* Intaglio. 13¼ x 20 inches (33.7 x 50.8 cm). The Metropolitan Museum of Art. The Elisha Whittelsey Collection, The Elisha Whittelsey Fund, 1963 (63.617.3). Image © 2006 The Metropolitan Museum of Art
PAGES 82–83, DETAIL

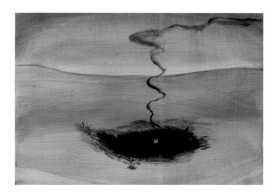

Kara Walker. *Entrance to the Underground Railroad* from the series *American Primitives*, 2001. Gouache and cut paper on paint board. Series of 36 plus 8 framed text. panels. 8 x 11 inches (20.3 x 27.9 cm). Collection of Rachel and Jean-Pierre Lehmann
PAGES 84–85

> Years ago I entertained the fantasy of
> my twin and I, my Good, evil twin, the
> one who doesn't exactly exist but
> manifests in the form of new friends-
> My twin and I taking a Racist for a Run
> The Ultimate seductress?
> causes a man to lose his belief, to lose his
> faith in himself, his laws and what better
> justified seduction could there be.
> the Sexual Sacrafice- Us colored
> women suffer this delusion of Grand
> martyrdom. Becoming new chirsts

Kara Walker. *Untitled* from the series *American Primitives*, 2001. Typewriting on index cards and found image. Series of 36 plus 8 framed text panels. Each card and panel 3 x 5 inches (7.62 x 12.7 cm). Collection of Rachel and Jean-Pierre Lehmann
PAGES 86–87

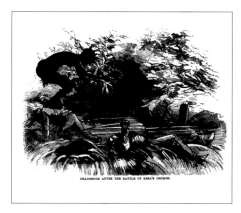

Kara Walker. *Deadbrook After the Battle of Ezra's Church. Harper's Pictorial History of the Civil War (Annotated)*, 2005. Portfolio of 15 offset lithography and silkscreen prints. Each: 39 x 53 inches (99 x 134.62 cm). The Metropolitan Museum of Art. Purchase, Dave and Reba Williams Gift, 2005 (2005.215.1-.15)
PAGES 88–89

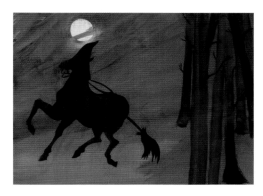

Kara Walker. *Familiar* from the series *American Primitives*, 2001. Gouache and cut paper on paint board. Series of 36 plus 8 framed text panels. 9 x 12 inches (22.9 x 30.5 cm). Collection of Rachel and Jean-Pierre Lehmann
PAGES 90–91

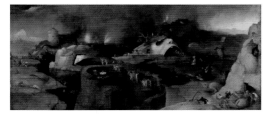

Style of Hieronymus Bosch (Netherlandish). *Christ's Descent into Hell*, ca. 1550–60. Oil on wood. 21 x 46 inches (53.3 x 116.8 cm). The Metropolitan Museum of Art. Harris Brisbane Dick Fund, 1926 (26.244). Photograph © 1986 The Metropolitan Museum of Art
PAGES 92–93, DETAIL

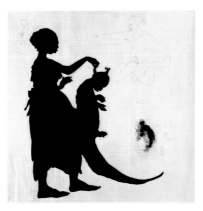

Kara Walker. *Untitled*, 1996. Cut paper, watercolor, and graphite on paper mounted on canvas. 69½ x 66 inches (176.5 x 167.6 cm). Private collection
PAGE 95

```
        Constructive criticism for
      plantation Lords.

      watch out.
```

Kara Walker. *Untitled* from the series *American Primitives*, 2001. Typewriting on index cards. Series of 36 plus 8 framed text panels. Each card 3 x 5 inches (7.62 x 12.7 cm). Collection of Rachel and Jean-Pierre Lehmann
PAGES 96–97

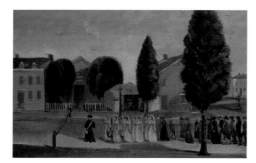

William P. Chappel (American, ca. 1800–1880). *Infant Funeral Procession*, 1870s. Oil on slate paper. 6¹⁄₁₆ x 9³⁄₁₆ inches (15.4 x 23.3 cm). The Metropolitan Museum of Art. The Edward W. C. Arnold Collection of New York Prints, Maps, and Pictures, Bequest of Edward W. C. Arnold, 1954 (54.90.502). Image © 2007 The Metropolitan Museum of Art
PAGES 98–99

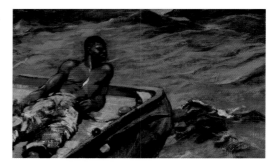

Winslow Homer, *The Gulf Stream*, 1899 (see entry on page 113 for complete caption)
PAGES 100–101, DETAIL

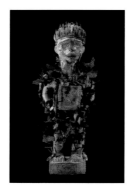

Unknown artist. *Male Power Figure (Nkisi)*, 19th century (see entry on page 109 for complete caption)
PAGE 103

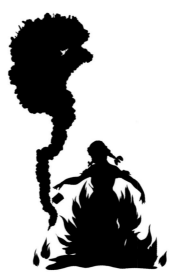

Kara Walker. *Burn*, 1998. Cut paper and adhesive. 92 x 48 inches (233.7 x 121.9 cm). The Speyer Family Collection, New York
PAGE 105

First published in the United States in 2007 by
Rizzoli International Publications, Inc.
300 Park Avenue South
New York, NY 10010
www.rizzoliusa.com

2007 2008 2009 2010/10 9 8 7 6 5 4 3 2 1

ISBN 10: 0-8478-2981-2
ISBN 13: 978-0-8478-2981-1

Library of Congress Control Number: 2007926138

Designed by Miko McGinty, assisted by Rita Jules

PRINTED IN CHINA